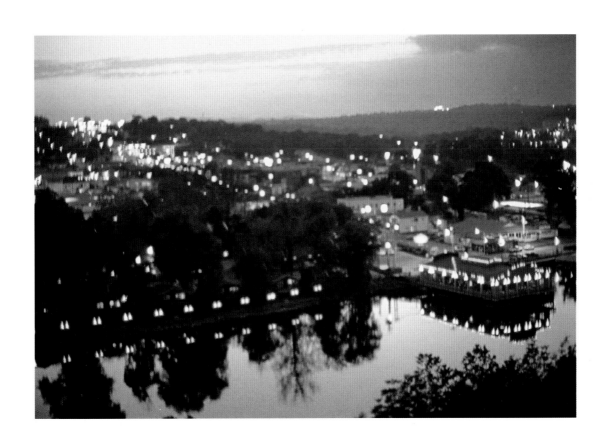

BRAN

LAS VEGAS O

ARTISAN NEW YORK

HENRY HORENSTEIN

S O N, M O
THE OZARKS

FOREWORD BY THE LENNON SISTERS

INTRODUCTION BY ALANNA NASH

This book is for Cat, Bill, Emily, Ole, Maggie, and Stella Anderson

Photographs and text copyright © 1998 Henry Horenstein
Introduction copyright © 1998 Alanna Nash
Foreword copyright © 1998 Lennon Sisters

All rights reserved. No portion of this book may be reproduced – mechanically, electronically, or by any other means, including photocopying – without written permission of the publisher.

Editor: Laurie Orseck
Designer: Alexandra Maldonado
Production Director: Hope Koturo

Library of Congress Cataloging-in-Publication Data
Horenstein, Henry.
Branson, MO / by Henry Horenstein
p. cm..
ISBN 1–885183–85-2
1. Country music–Missouri–Branson–Pictorial works. 2. Branson (MO.)–Pictorial works. I. Title
ML3524.H66 1998
 781.642'09778'797–dc21 97–46123
 cip
 MN

Published in 1998 by Artisan,
a division of Workman Publishing Company, Inc.
708 Broadway, New York, NY 10003

Printed in Italy
10 9 8 7 6 5 4 3 2 1
First Printing

THANKS

So many people helped put this book together. Very special thanks to Dan Lennon, the Lennon Sisters and Brothers, and their families at the Welk Champagne Theater for being helpful and supportive in so many ways. And to Alanna Nash for her fine introduction and professional attitude. In Branson, Tricia Smith of the Branson Chamber of Commerce was enormously helpful and responsive. Assisting me ably on location were Andrea Raynor and Tim Garrett. Longtime Branson residents Bob Moskop and Ernestine Riley filled in a lot of the area's history. Many of the entertainers and show people also helped a lot, in particular John and Susie Foley of the Pump Boys and Dinettes and Bill Daley. At home in Boston, Tom Gearty and Megan Doyle kept me on schedule. Tom, Hadley Stern, and Andrea Raynor helped edit the pictures, Tom edited and tightened up the text, and Jane Roberts chipped in to keep us all organized. Many thanks to all.

CONTENTS

E N T S

FOREWORD

When Larry Welk, Jr. first talked to us in California about doing "a little hosting" for the new live Lawrence Welk Show he was putting together in Branson, we said, "Where in the world is Branson?" We were soon to find out—and we underwent the same Branson "conversion" that Larry and millions of other people have experienced over the last few years.

From the moment we first drove through the rolling green hills, glimpsed the edge of a sparkling blue lake through the dogwoods at Silver Dollar City, and smelled the aroma of home-cooked food through the window of a lakeside cottage . . . well, we were hooked. We began to meet the people of these hills: the Herschends, the Presleys, the Mabes, and so many others—open, friendly, proud of their rich heritage. Our longtime friends John Davidson, Andy Williams, the Osmonds all beckoned to us to come to this small Missouri town to do what we love to do in front of appreciative people who can't seem to get enough of traditional American music.

We went to the shows—Mel Tillis, Bobby Vinton, Shoji Tabuchi, Mickey Gilley. At Jim Stafford's, we were but a few of the 1,200 people who, sides already sore from laughing, softly sang "You Are My Sunshine" along with Jim all the way through—and then sat in the ensuing quiet, savoring the simplicity of a pleasant song in an increasingly complicated world. At the Andy Williams Show, after all his hectic years on the road, we saw a happy and relaxed Andy on the stage of his own magnificent Moon River Theater. Nearly forty years after we met a young singing family from Utah struggling to make its way in show business, we saw a quintet of Osmond Brothers singing joyously onstage with their talented children, as well as Mom and Dad Osmond.

And walking under the clear, starry Ozark sky, it felt to us like a magical land of renewal, where dreams somehow have a better chance of coming true. (It still does.)

In the spring of 1994, thirty members of our family moved from California to Branson. "A little hosting" has become a new life for us Lennon Sisters—and for our brothers, sons, and daughters—as year-round featured performers with Jo Ann Castle at the Welk Champagne Theater, set among the peaceful hills surrounding Lake Taneycomo. And we have been welcomed into a community that still believes our best days are ahead of us.

As you travel through the pages of this lovely book, see if you don't feel that curious sense of longing, and familiarity, and contentment that Branson can bring.

THE LENNON SISTERS
Dee Dee, Peggy, Kathy, & Janet

God bless you The Lennon Sisters

Kathy Janet Peggy Dee Dee

INTRODUCTION

For roughly a century, Branson, Missouri, semi-isolated in a remote corner of the Ozarks some 250 miles southwest of St. Louis, lazed away minding its own business as a wide place in the road, a sleepy little stopping-off place for hunting and fishing enthusiasts who came to the area for a mountain vacation.

Today the music boom town, named for postmaster Reuben Branson in 1882, is such an explosive show business capital—one to rival not just Nashville, but New York, Las Vegas, and Los Angeles—that it might well be called the Middle Coast.

Exactly how Branson turned into an entertainment, business, social, artistic, and cultural phenomenon isn't precisely clear. This much is known: In 1960, the still-operating Baldknobbers Hillbilly Jamboree Show, founded by the Mabe Brothers, who accompanied themselves on such primitive instruments as the washboard, washtub bass, and jackass jawbone, started putting on Saturday night shows downtown by Lake Taneycomo. A cou-

ple of years later, the cast and crew of "The Beverly Hillbillies," the wildly popular 1960s sitcom, came to Branson to film a few episodes at Silver Dollar City, an Ozarks heritage showcase and theme park modeled after a mining village. Several fans liked what they saw enough to move on down. In 1967, the Presley family (no relation to Elvis) opened their Presleys' Mountain Music Jubilee as the first show on State Route 76, now better known as "76 Country Boulevard."

The Presleys, like the Baldknobbers, hardly traded in sophisticated humor ("Have your eyes ever been checked?" "No, they've always been blue"). Three generations later, they're still doing the kind of cornpone jokes ("My girlfriend's trying to get back to her original weight." "What's that?" "Six pounds, eleven ounces.") that almost anyone can enjoy, and that made their humble little theater a success right off the bat.

By 1973, the Plummer Family Country Music Show moved

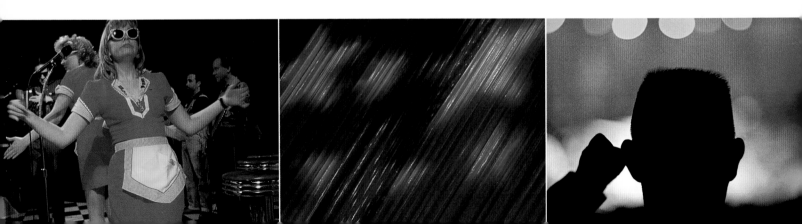

in to put down roots, and the Foggy River Boys also came courting the Ozark entertainment dollars. In 1981, there were no fewer than eleven such shows in the area, most featuring the stereotypical hillbilly fiddle-playin' overall-wearin' corncob pipe-smokin' slapstick humor-tradin' characters that folks all over the country came to love from "Hee Haw." Baldknobbers and the Presleys remain Branson's foundation theaters. They still draw as well as ever, and they still feature an old-time mountain musical heritage. But while the performers' sound retains its original purity and spark, their mix of country, gospel, light rock 'n' roll, and patriotic songs now has a more modern edge. Their costumes have also changed, and, as they put it, "The stage has more glitz and polish." It had to, to survive. Because in 1983, something extraordinary happened that would change the sleepy little hamlet forever.

It started with Roy Clark, who in the early eighties picked up the "Hee Haw" thread and ran with it all the way down to Branson, where he stuck his name on a theater and waited for the fans to come.

And come they did. But they weren't the only ones. Two years later, the Sons of the Pioneers, the legendary cowboy music singers who first organized in 1934, saddled up and rode to town. Pretty soon, an outright migration took form. In 1987, Boxcar Willie caught a freight and came on down from Nashville, followed by Jim Stafford, Mickey Gilley, Mel Tillis, Ray Stevens, and Cristy Lane—some of whom cut out the middlemen and built their own theaters on a bodacious strip of fried-food restaurants, wax museums, and water slides. Naturally, their friends—Loretta Lynn, Conway Twitty, Glenn Campbell, Crystal Gayle, Louise Mandrell, Merle Haggard, Willie Nelson—came to visit, pulled up a chair, and stayed a while.

In no time, Branson was billing itself as America's Country

Music Show Capital. And for good reason. The nearly 6 million fans who packed the town's theaters each year could see more shows there in a three-day period than they could catch anyplace else in a month. "You go to Nashville, you see the stars' homes," Mel Tillis said. "You come to Branson, you see the stars."

It was a win-win situation all around. The stars liked it because after ten, twenty, or even thirty years of one-nighters, they could come off the road, settle down, and sleep in their own beds. Instead of going to the people, the people came to them.

"Guy told me one time, 'You finally get to put your stuff in the drawer,'" Moe Bandy explained. "It's Hillbilly Heaven without the halo and wings," Tillis added.

Certainly that was also true financially. "'60 Minutes' asked me if you could make six million dollars in six months here," the Ol' Stutterer said a couple of years back. "That's pretty close."

"I've heard figures that people come here and spend as much as a billion and a half dollars in this little strip," Roy Clark said in 1991. Which probably makes Branson, per capita, the richest town in America. "By golly, we're glad to have you here tonight," Boxcar Willie always told audiences. "Come to think of it, it's a financial pleasure to have you here!"

As Branson began to catch on, stealing the tourist dollars out of Nashville, where country music is mostly an export instead of a live performance commodity, the joke, related Waylon Jennings, is that somebody put up a sign in Music City that read, "Will the last one to leave Nashville for Branson please turn out the lights?" Some in the Nashville music industry retaliate by thumbing their nose, saying Branson is little more than a resting place for performers whose hit-making radio days are long behind them.

But who's resting? Most performers usually do two shows a day, seven to nine months a year. And the after-show "meet 'n' greet," where the stars shake hands and sign autographs for hours, is de rigueur, part of the almost sacred bond between country performers and the fans who made them what they are. Yet even though the match seemed perfect between the mountains, with their timeless beauty, and a music that seemed as old as the hills, underneath this bucolic calm lay a ripple of restlessness. Nashville's Grand Ole Opry may still have been "poetry in polyester," as singer/songwriter Hal Ketchum once described it, but by the mid-1990s Branson had moved on to become sonnets in glitter and spandex as the Vegas acts began moving to town and taking the music down the middle of the road.

Andy Williams was the first, opening his 2,000-seat Moon River Theater across the street from the new, upscale 4,000-seat Grand Palace in May 1992. Then came singers Wayne Newton, Tony Orlando, and Bobby Vinton; the nostalgia-laced Lawrence Welk Show and the Lennon Brothers Breakfast Show; the blond and pleasing Jennifer "In the Morning" Wilson; the Liberace-ized piano man Dino Kartsonakis; the ever-popular all-American Osmonds; the once controversial former Miss America Anita Bryant; and comedian Yakov Smirnoff, whose new theater, shopping, and dining complex, Yakov's American Pavilion, was in part sponsored by American Airlines—a most fitting backer, considering the Russian-born Smirnoff's pride in becoming a U.S. citizen a decade before.

These performers brought a degree of sophistication to their acts that the country performers couldn't, and their shows, many of which were laser-lit extravaganzas with big production budgets, called for the stars to wear something more akin to sequined tuxedos than tattered overalls.

Audiences loved them. It wasn't exactly country, but it was wholesome, and that was the general idea. As Las Vegas itself became more family oriented and the performers' material changed to please that audience, it made sense for some of those acts to come on down to Branson, too. Suddenly, the town wasn't just America's Country Music Capital; it was America's Live Entertainment Capital. The emphasis was now on shows, not concerts, with audience interaction and comedy. That drew younger families to the area, particularly in the summer, and foreign tourists to mix with the core audience of older visitors on bus tours.

And Branson was only too glad to have it that way, as competition sprang up across the country, places like Myrtle Beach, South Carolina, and Pigeon Forge, Tennessee, copying Branson's music theater idea and wooing away country performers like the Gatlin Brothers, who had planned first on building their performance halls in the Ozarks. Branson was hit hard, too, by the impact of legalized gambling in places like Tunica, Mississippi, and Evansville, Indiana, where folks decided to stay closer to home rather than travel to Missouri.

One of the performers for whom Branson is a kind of "homecoming" is Brenda Lee, whose career has ranged from country to rock to pop, but whose bookings for the last several decades have included long engagements in the lounges of Las Vegas and Reno. A major break in her career as a child was

performing on Red Foley's "Ozark Jubilee" television show, which originated in nearby Springfield, Missouri. And she's been performing in Branson since the early eighties.

"As the town has grown into a major entertainment capital, it's attracted a much bigger and more diverse audience," says the diminutive star. "But having performed all over the world, I have been in front of audiences that have run the full spectrum in sophistication, culture, and affluence. And in coming to Branson, I've been really impressed with these audiences—they know how to enjoy themselves and have fun."

Dan Lennon of the Lennon Brothers agrees. "I think what people have in common here is that it is a place to experience traditional American entertainment of all kinds," he says. "It is true that you could take your grandmother and your two-year-old daughter to all the shows here and not be offended by anything you saw or heard. You'd also have a heck of a good time."

The musicians are having a fine time as well. Branson is probably viewed as more conservative than it really is, since late-night blues and jazz spots have been opening now, too. The musicians who play the swing standards of the forties in the Welk and Lennon shows get tired of playing charts for two shows a day, six days a week, so they unwind and let loose at Rocky's and at the Stage Door Canteen.

Many Branson visitors return time after time, especially when new performers come to the area, or when theaters change, like the time Wayne Newton gave up his own venue and teamed up with Tony Orlando.

But for the most part, they go to Branson to reaffirm their beliefs in a time-honored way of life. A heartland way of life, where family values aren't just some politician's trendy buzzwords, patriotism still counts for something, and the big, emotional show finales that reinforce those personal creeds are something vital and real in the minds and hearts and souls of the audience.

One irony of Branson is that it is a center of make-believe set smack in the middle of the some of the most organic, natural beauty in the country, the neon-laced theaters looking somewhat surrealistic against the backdrop of God's own architecture. But the majority of the people who come here now don't so much care about the undulating hills, the rich, verdant woods, or the teeming wildlife. The visitors, who come dressed in plain garb in contrast to the nighttime finery of their heroes and the glossy new theaters that line the five-mile "Strip," are far more interested in

glittering stars than in the twinkling variety found in the skies.

Just what will become of this amazing oasis of entertainment called Branson? Nobody really knows. At some point, the country performers may reclaim their turf, but it doesn't look as if that will happen anytime soon. Charley Pride is one of the few old-style acts to move there in recent years, as Roy Clark and some of Branson's other premier pick 'n' grin stars have packed up and hit the trail.

Of course, there are other changes. The old postmaster Reuben Branson wouldn't recognize the town now. The area is growing so rapidly that it accounts for 20 percent of Missouri's growth since 1990. Seems that a lot of folks who came here as tourists want to come back and become residents. They feel comfortable here, for reasons they may not even comprehend. But Yakov Smirnoff thinks he knows why.

"Ten years ago I was sworn in as an American citizen, standing in the shadow of the Statue of Liberty," he recalls. "All around me I saw people from different lands who, like me, were proud to become a part of this great nation. . . . We may have left many things behind, but we also brought many things with us—wonderful things that create the backbone of this country: honor, character, hard work, integrity. As I looked around at those new Americans,

I knew that some day, in some way, I would create a place where we accept and celebrate all the cultures that make up America."

In a small way, Branson itself is a microcosm of that assimilation—of styles, of tastes, of political and religious affiliations. At once universal and uniquely American, it is a place where dreams come true, both for the performers and for the audience, three shows a day, seven to nine months a year. At the core of its sequined soul, Branson is neither hillbilly nor Hollywood/Vegas. It is a virtual fantasyland in the hills, a geographically indeterminate playground of the heart.

To most photojournalists, the bustle of buses and tourists would be a show in itself. But the camera of Henry Horenstein, whose photographs fill these pages, remains straightforward, unjudgmental, and full of fun. Horenstein sees Branson for what it is—a fascinating comingling of simple-hearted small-town innocence, the vulgarity and excitement of Vegas, and the manufactured exuberance of Disney World. In the following pages, he proves a very able guide.

ALANNA NASH

Yes, there are natives of Branson—about 4,000 of them—though most tourists never meet them. They eat lunch at Penelope's Restaurant and celebrate birthdays and special events with dinner at the Candlestick Inn. They take their kids to school in the morning and pick them up in the afternoon. They pray at the huge First Baptist Church or one of the other 150 or so churches in town. And their kids play Little League at Stockstill Park. They're at the Osmond Family Theater or the Baldknobber's Show, though they're practically invisible behind the millions of visitors who pass through town. But for every business that prospers from the tourism, such as Dick's Five-and-Dime Store on Main Street, there are others like Skate World that are largely unaffected by the influx of tourists. Except, perhaps, for the famous traffic jams.

Adults who were born in Branson have seen enormous changes in recent years. But there are some things that remain the same. Ask anyone in town and they'll tell you it's still a great place to live and raise a family: caring neighbors, natural beauty, hardly any crime—and great golf courses.

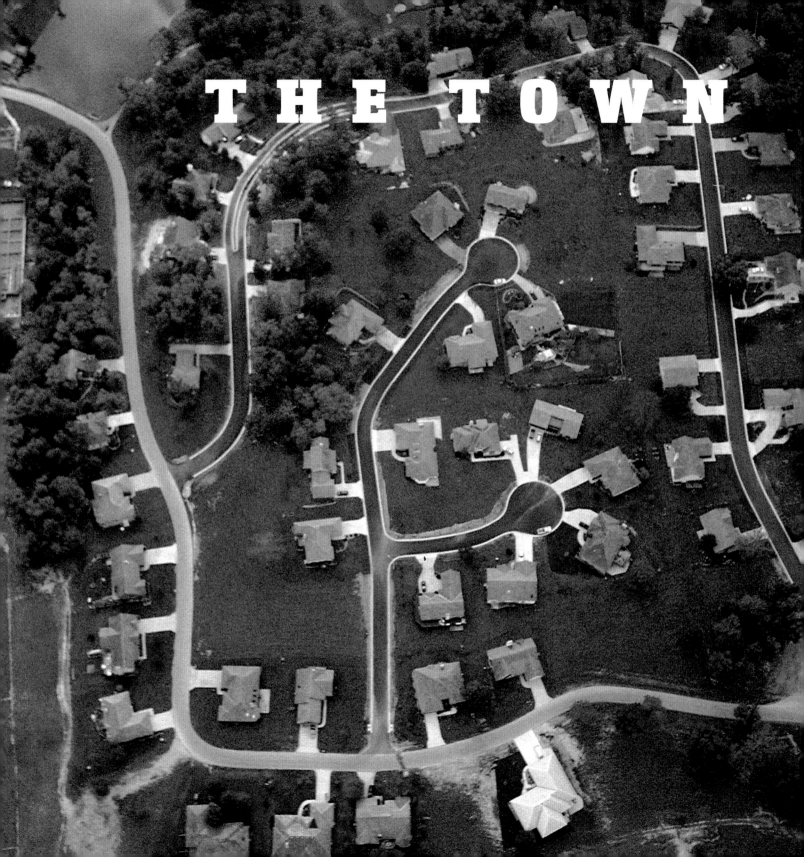

THE TOWN

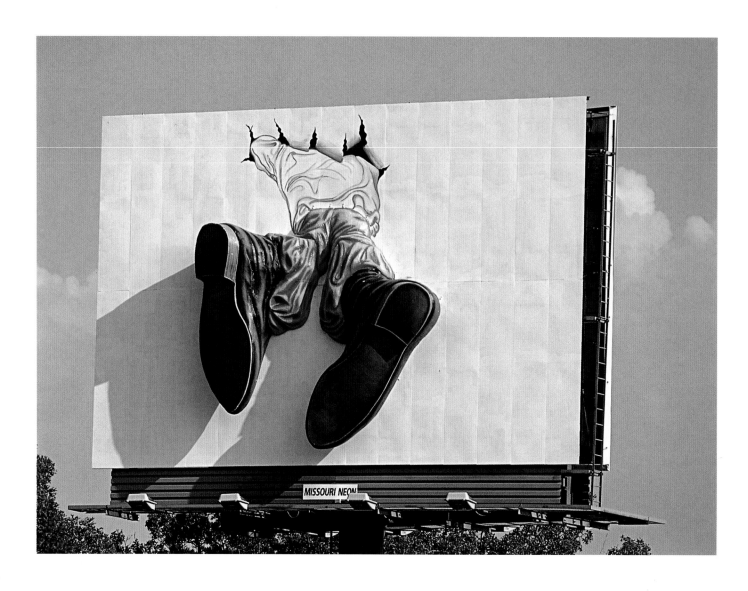

ROUTE 165

Billboards are ubiquitous in Branson
and on all roads leading to town. On one,
comedian Yakov Smirnoff's feet burst
out one side; his head comes out the other!

SADDLE UP

Guitars and Cadillacs is one of the few
nightclubs catering to all ages. A revolving
disco saddle hanging from the ceiling
provides the lighting and sets the mood.

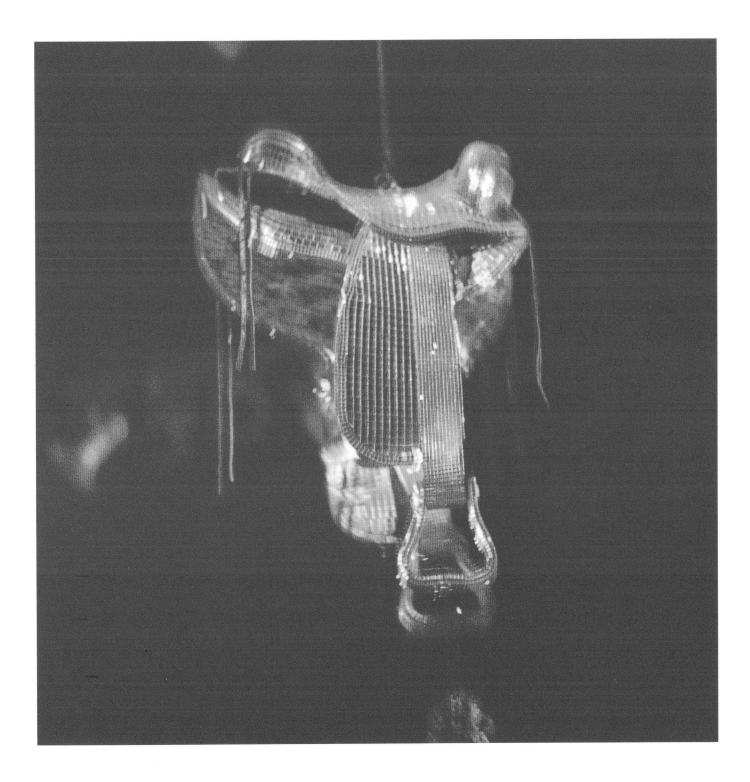

NIGHT MOVES

Every evening offers something different at Guitars and Cadillacs. The roster of events runs the gamut from teen dances to the ever-popular karaoke show.

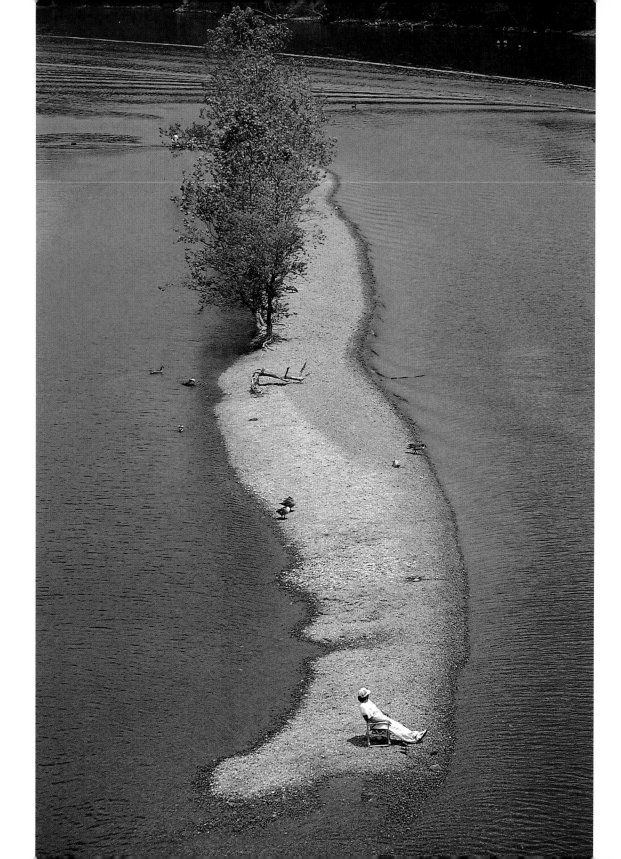

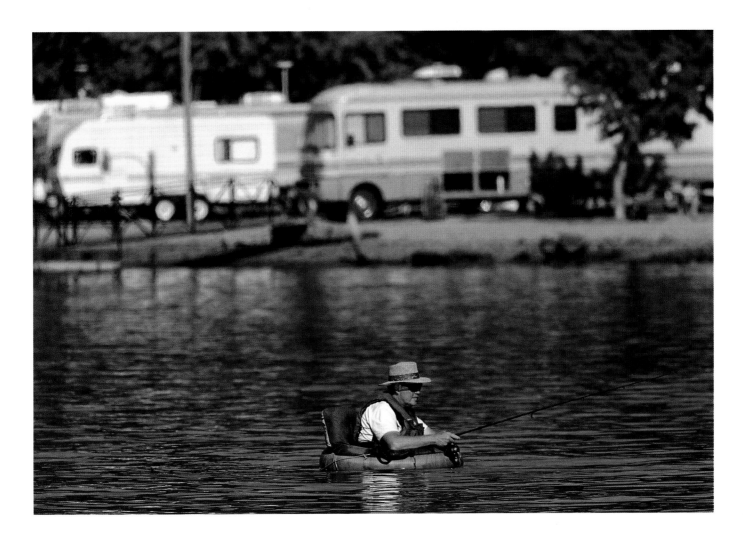

FISHING, LAKE TANEYCOMO

Fishing, hunting, and other outdoor activities brought visitors to Branson long before the invasion of the entertainment industry. Today, the joys of the outdoor life are somewhat eclipsed by strip malls and neon lights, but an oasis of incredible natural beauty still exists. Lakes are filled with trout; lakesides are filled with RVs, trailers, and campgrounds.

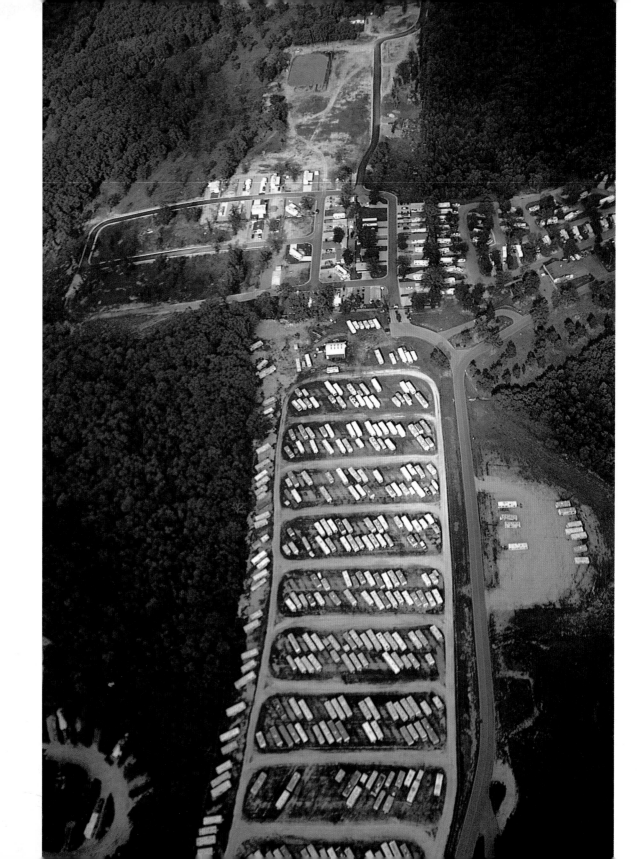

VISITORS AND VISITED

Though there are plenty of hotels and motels, many tourists bring their own accommodations in the form of trailers and RVs (opposite). But Branson and its neighboring towns do have natives. Ernestine Riley (left) is from Hollister, Missouri; her brother was a popular fiddler at Shepherd of the Hills, one of the area's first tourist attractions.

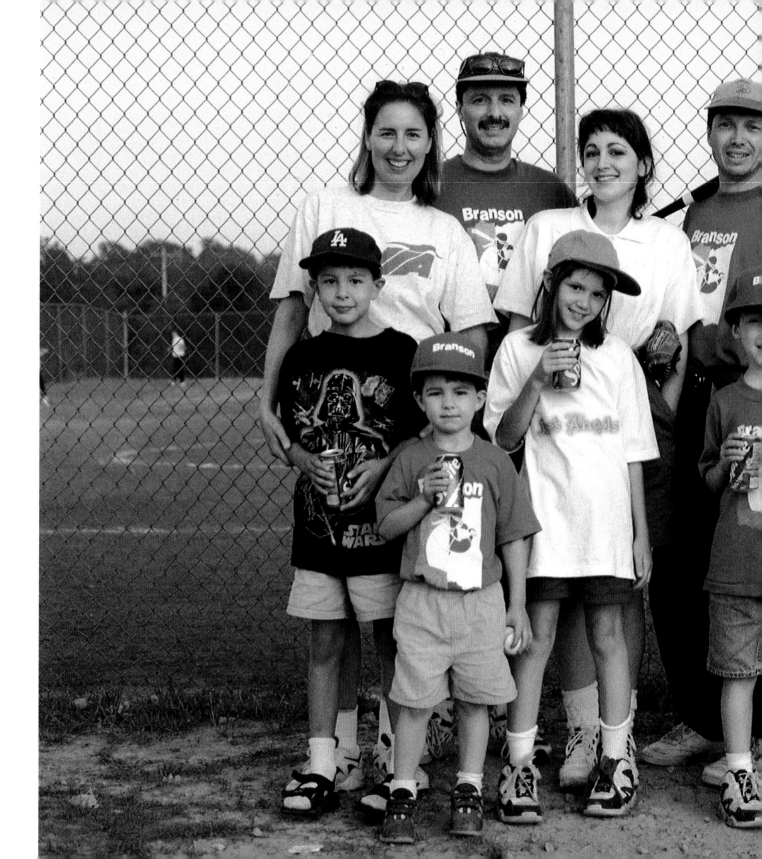

FAMILY VALUES

Thirty members of the Lennon family—three generations—moved to Branson in 1994 from California, where they had lived all their lives. The town is nearly ideal for raising children, but the real draw was the ability to work full-time as a family in the entertainment industry.

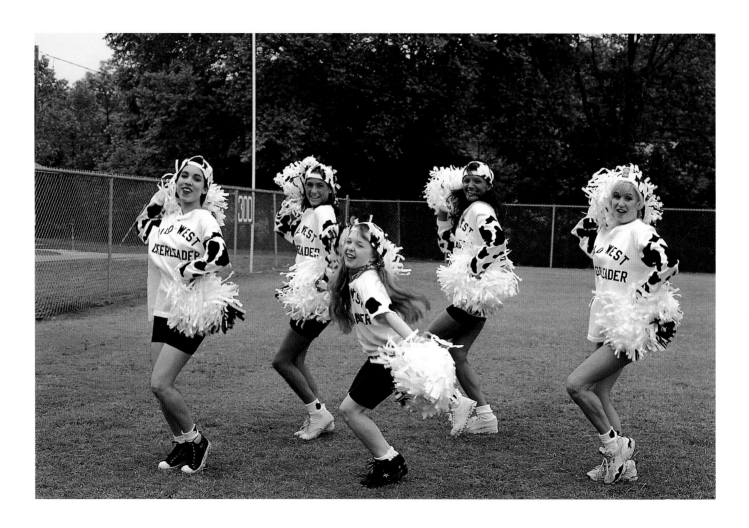

CALL OF THE WILD WEST

Like small towns across the country, Branson has a softball league. It's just that the teams made up of entertainers and staff from the various theaters are a little more colorful than most.

ANDY WILLIAMS AT HOME

Many entertainers live in town as well, including Andy Williams, a full-time resident. He's also the town's premier art collector; his home and theater are filled with masterpieces, from Henry Moore sculptures to De Kooning canvases.

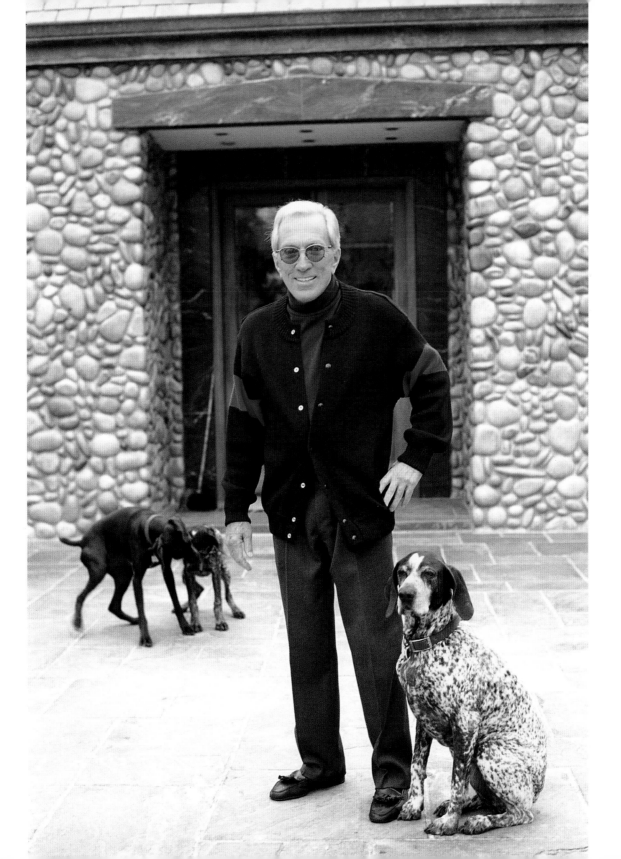

There are about three dozen theaters in Branson, hosting more than seventy-five different shows. Some are large halls for big productions, like the Grand Palace (3,812 seats). Others are more intimate, places to enjoy a meal and a show at the same time, like the Pump Boys and Dinettes Dinner Theater (522 seats). Sometimes the theater itself is as much of a spectacle as the performance—the million-dollar bathrooms at the Shoji Tabuchi Theater are always the subject of much talk. All are within a few miles of each other, and the shows mostly start at the same times. But this means that traffic keeps to the same schedule, and enormous traffic jams can make a half-hour trip out of a two-mile drive. Seasoned visitors know to leave their motels early.

Every year there is something different. Performers move over or move on. Theaters change names, change hands. A new face comes in and starts up. "Did you hear that Wayne Newton and Tony Orlando moved to the old Glenn Campbell Theater?" "Yakov Smirnoff has built his own place." It may seem like idle talk, but to the fan who comes back every year, it's like catching up with an old friend.

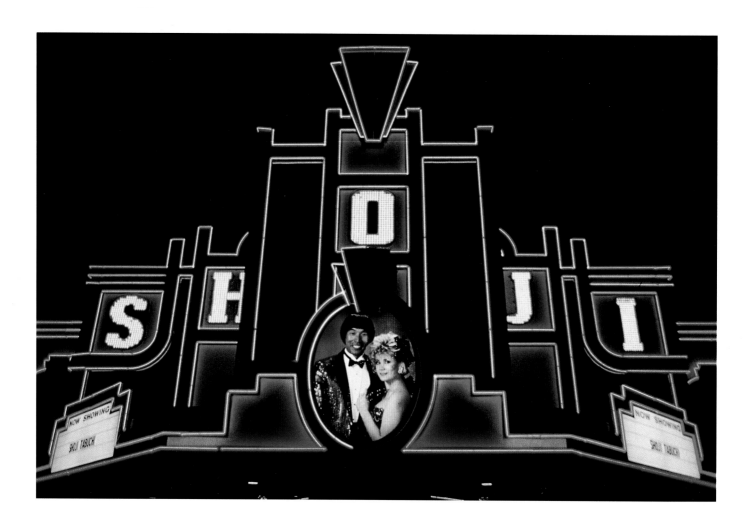

TALK OF THE TOWN

Shoji Tabuchi's theater is one of the most elaborate. The Vegas-style marquee features a portrait of the entertainer and his wife, Dorothy. The interior is equally over the top: The entrance lobby is a hint of things to come—a glittering gift shop upstairs, and those famously ornate bathrooms.

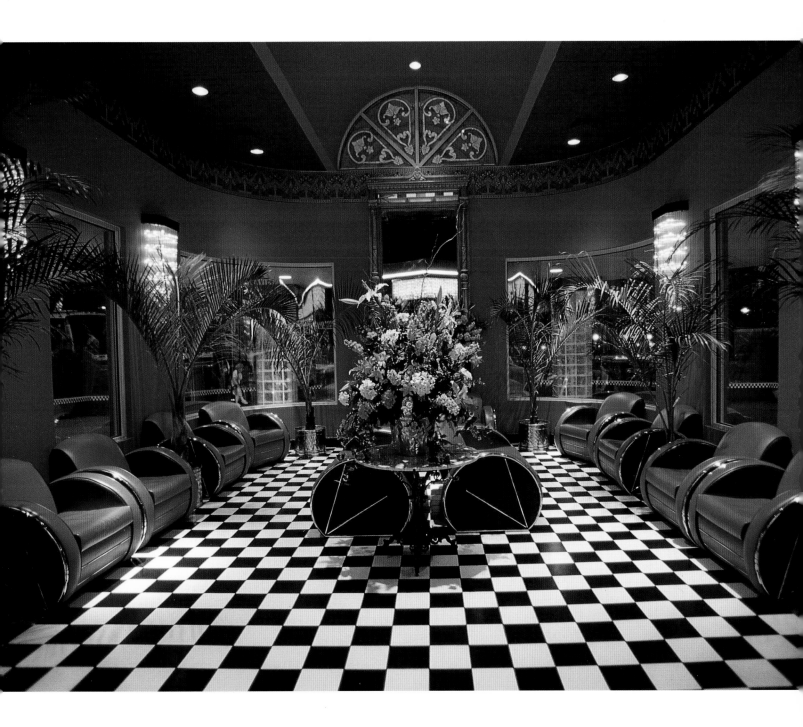

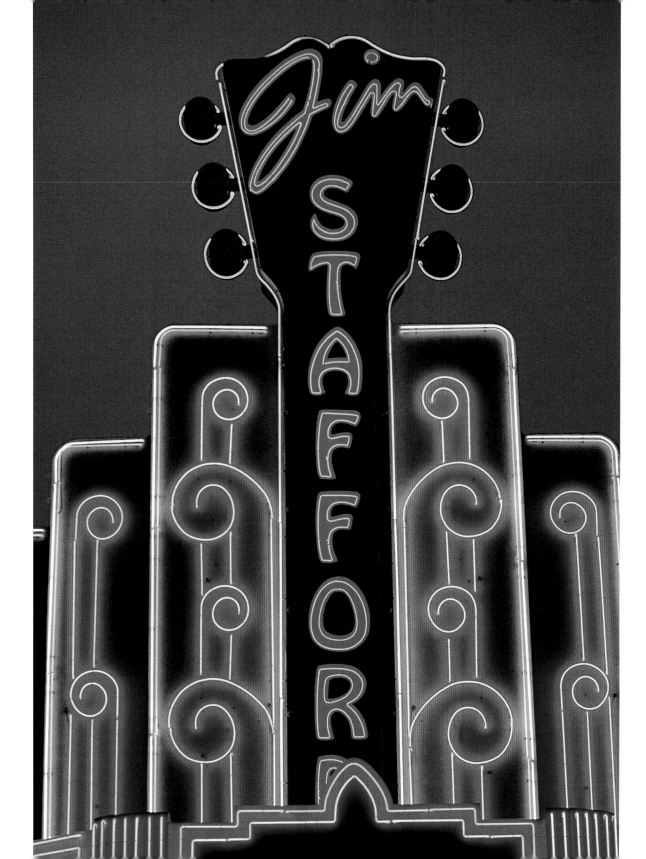

UP IN LIGHTS

The marquees on Highway 76 run

the gamut from plain and simple

to neon glitz, often reflecting the shows

inside. Jim Stafford's guitar marquee

is splashy and fun, just like Jim's show.

INSIDE STORY

The painted walls of the Wild West Show

Theater are truly impressive, but they

pale in comparison with the magnificent

Ozark landscape on the other side.

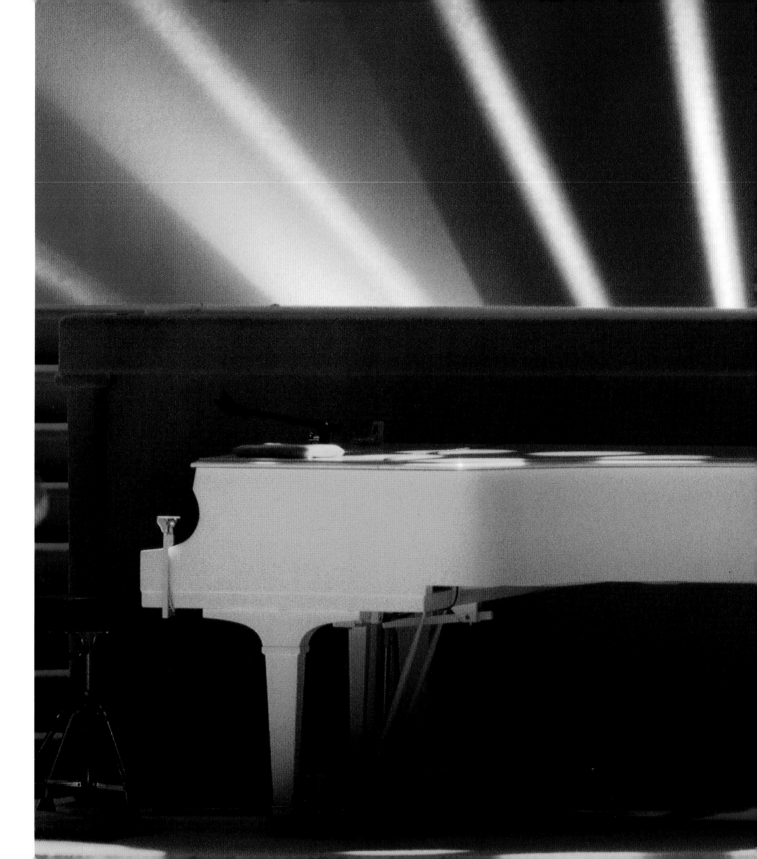

MICKEY'S PULPIT

*Perhaps best known as the co-owner
of Gilley's, the nightclub featured in the
film* Urban Cowboy, *Mickey Gilley is
a cousin to another famous piano player,
Jerry Lee Lewis, and the Reverend
Jimmy Swaggart. He can sing, entertain,
and preach with Branson's best.*

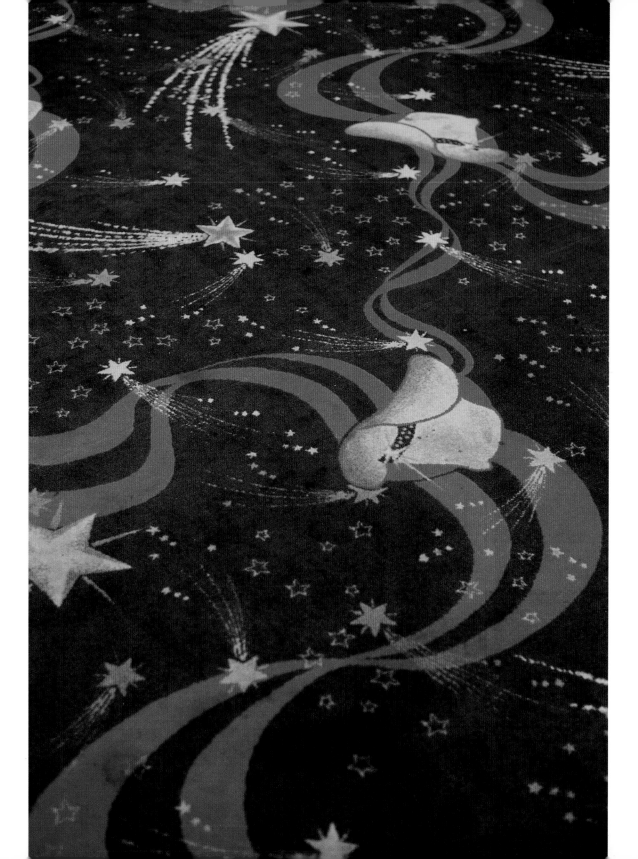

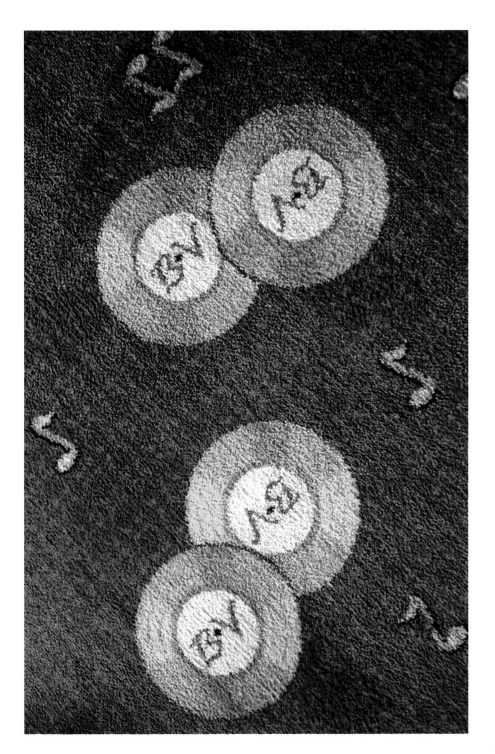

FLOORED

Points of interest in Branson theaters

often include elaborate carpeting.

A cowboy motif stretches throughout the

Country Tonite Theater (opposite).

Underfoot at Bobby Vinton's Blue Velvet

(BV) Theater is a reminder of the owner's

great success as a recording artist (left).

Some of the best shows in Branson are the most intimate ones. The Sons of the Pioneers remind us why we have always loved the American cowboy in songs and in small talk. The Lennon Brothers "Breakfast Show" brings back a feeling of the 1940s and 1950s with tight harmonies, a smoking-hot band, and a tasty buffet table. Still, there is no denying the appeal of the larger and slicker shows. Shoji Tabuchi is certainly a fine fiddler, but his show is as visual as it is musical—fog, lights, and drama.

Regardless of size, each show has its own character, of course, which is shaped largely by its headliner. Andy Williams is the consummate pro. Van Burch and Welford are unpredictable, Jim Stafford is nutty. Charley Pride is homey, Anita Bryant is emotional.

Some headliners, such as Tabuchi, rarely tour. Their success is home-grown. Others have an international reputation—the Lennon Sisters, Andy Williams, Bobby Vinton. They have traveled and performed everywhere, but in the end they'd rather be in Branson.

THE HEADLINERS

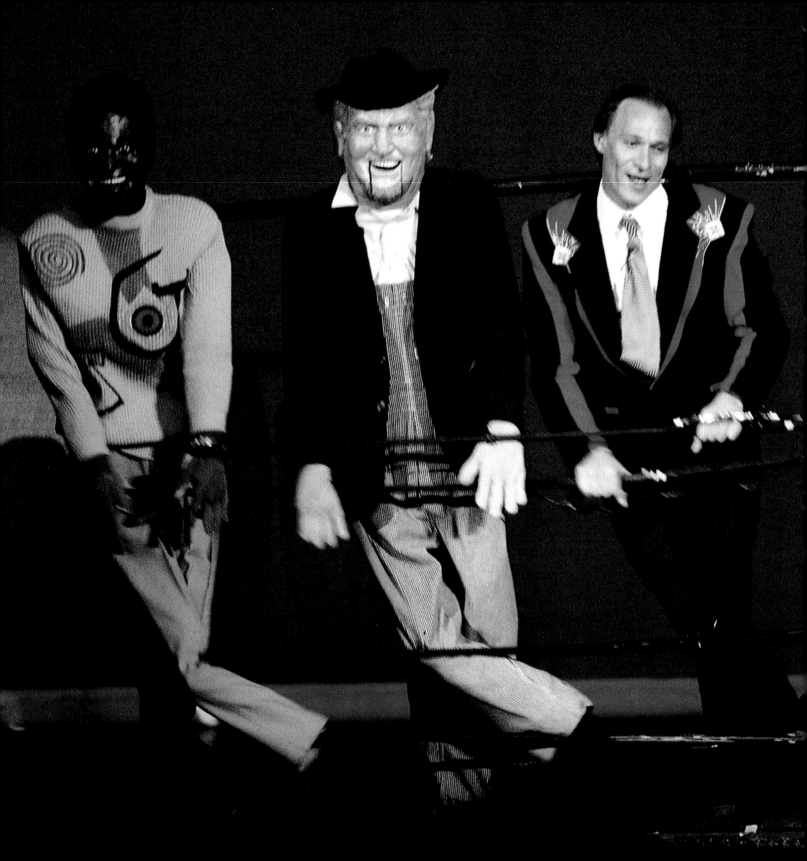

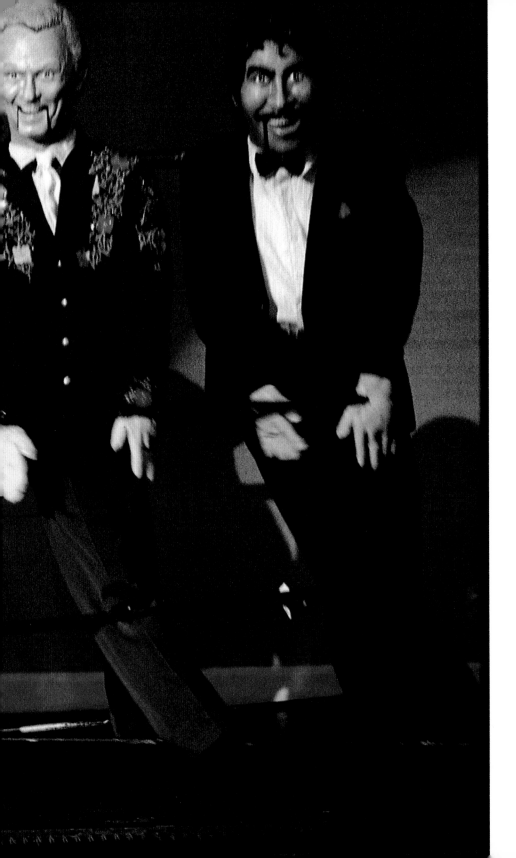

MAKE-BELIEVE

A comedian and juggler who worked with Andy Williams for years, Philip Welford now co-headlines his own show with illusionist Kirby Van Burch. One of his most popular bits is a show with life-size puppets of fellow stars Charley Pride, Boxcar Willie, Mel Tillis, and Tony Orlando.

SIGNING AUTOGRAPHS

Brenda Lee, who started her career almost fifty years ago at the age of six, is one of the most enduring figures in rock and country music. She's always available to sign autographs for fans after her shows.

VIDEO STAR

Ferlin Husky represents the older Branson style—straight country music with strong honky-tonk sentiments. Among his biggest hits are "Gone" (1957) and "Wings of a Dove" (1960).

GUITAR SOLO

*Jim Stafford's signature song, "Spiders
and Snakes," was a hit twenty years ago.
Today he is one of Branson's most versatile
and successful performers, combining music
and comedy in his family-oriented show.*

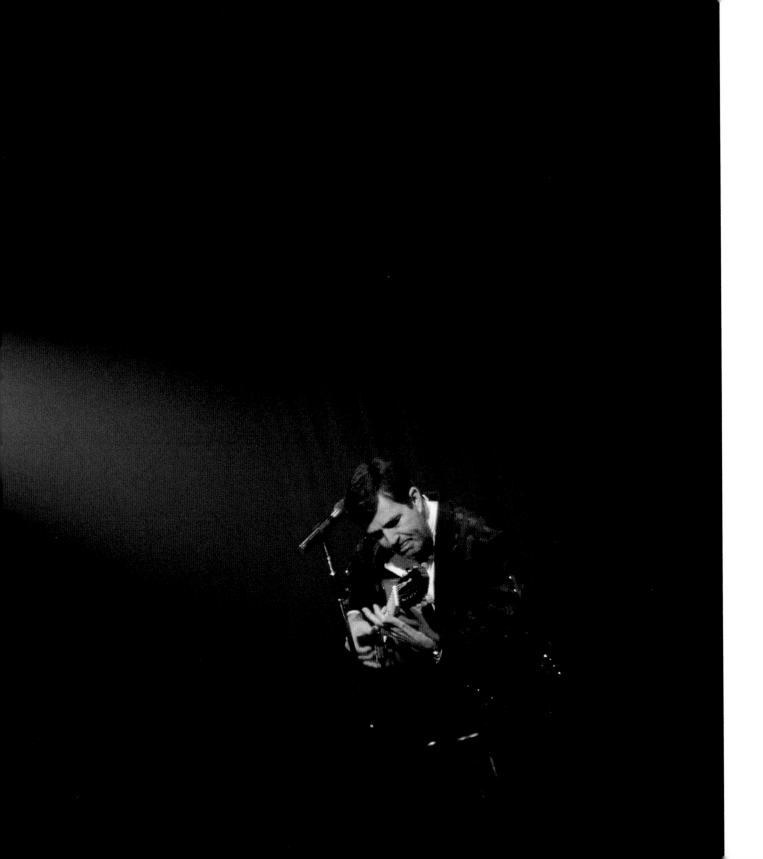

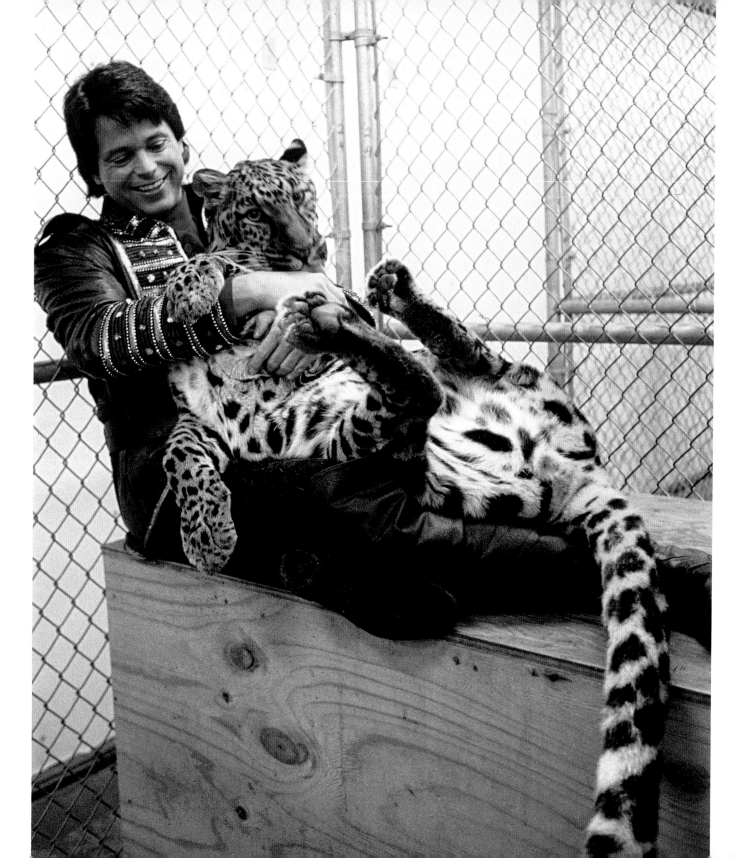

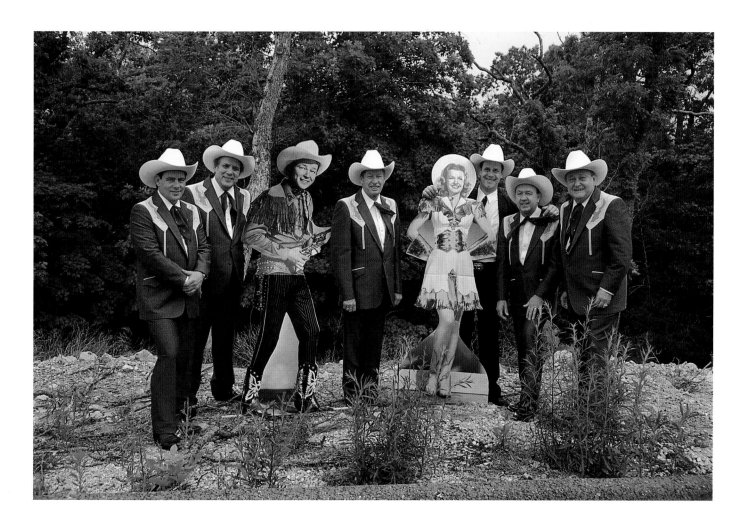

VAN BURCH AND FRIEND

*Illusionist Kirby Van Burch's antics
with his big cats make his show a favorite
with visitors of all ages. After the show
fans are invited backstage to visit the
animals—from outside the cages, of course.*

SONS OF THE PIONEERS

*One of the original cowboy bands, the Sons
of the Pioneers was founded in 1934 with
Roy Rogers, Bob Nolan, and Tim Spencer.
They appeared in dozens of movies and
made classic Western music such as "Cool
Water" and "Tumbling Tumbleweeds."*

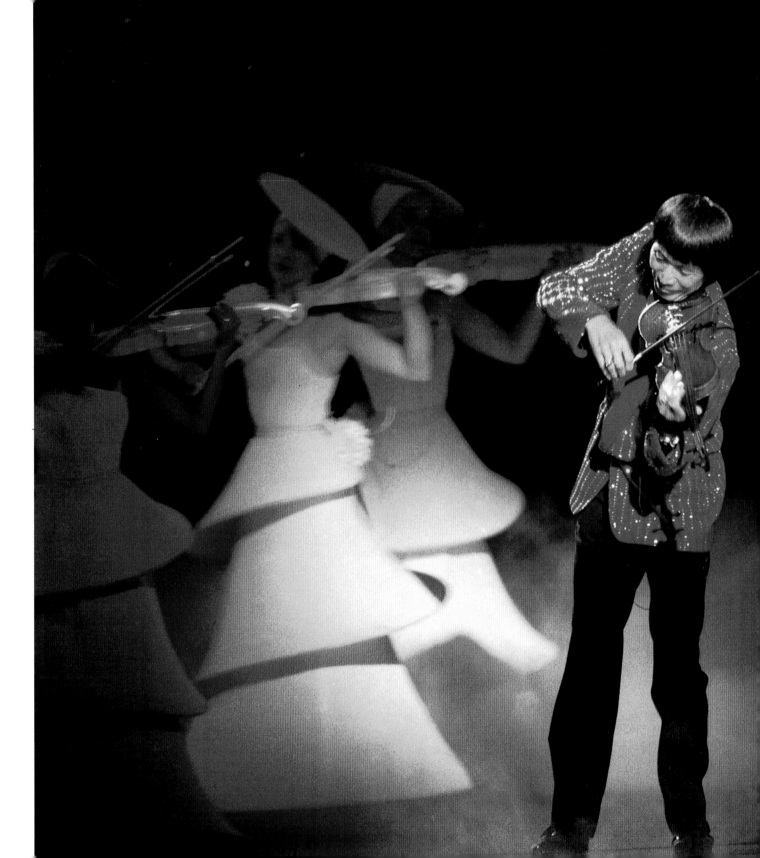

HOMETOWN TALENT

*If you go to Branson, you really should
see Shoji Tabuchi, if for no other reason
than you won't see him elsewhere.
But no one is more popular in Branson,
and his laser-packed show delivers on
the glitzy promise of his theater.*

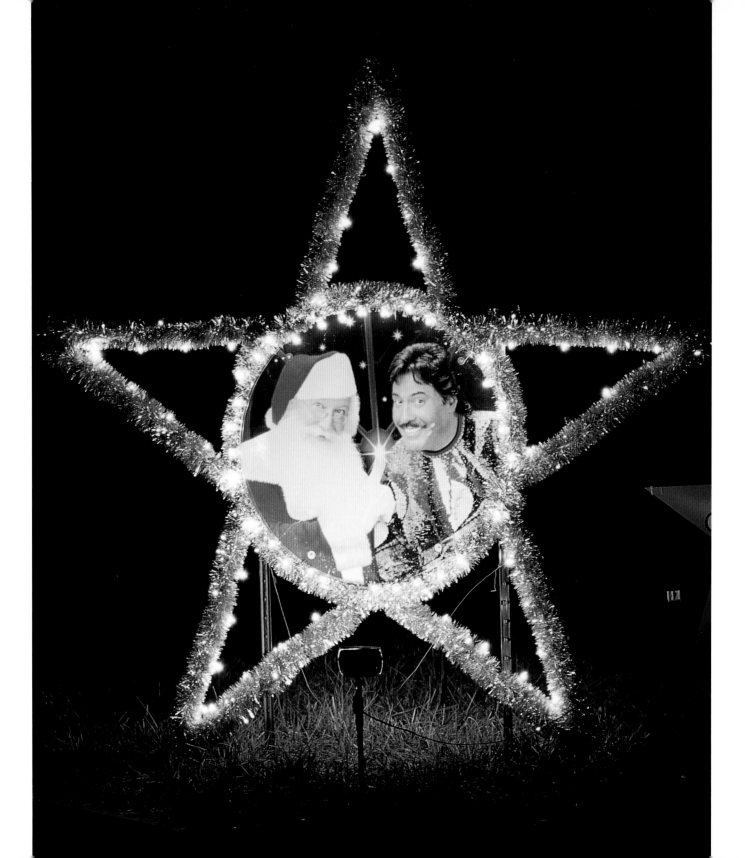

TONY MINUS DAWN

*Tony Orlando is a major headliner,
and another example of the town's move
away from a strictly country format
to soft rock and easy-listening pop. He's
pictured here with Santa Claus at the
Festival of Lights Parkway.*

SINGING GOSPEL

*Barbara Fairchild, whose biggest hit
was "The Teddy Bear Song" in 1973,
serves up a smooth blend of country
music, religious tunes, and cornball
comedy—a formula that helped put
Branson on the map.*

WAYNE REDUX

No one symbolizes the Vegas side of Branson more than Wayne Newton. But his show is surprisingly simple. It has no elaborate sets, lighting displays, supporting dancers, or trained dogs—just a tight band, a wide range of music, and a lot of Wayne.

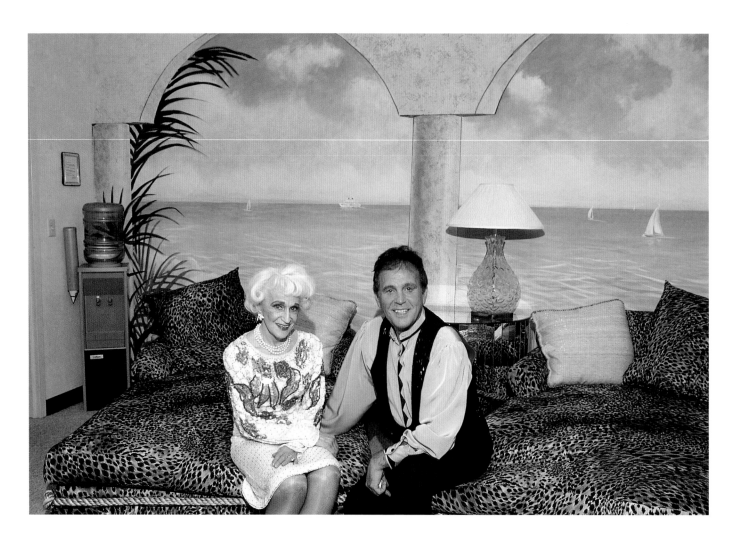

BACKSTAGE WITH MOM

Bobby Vinton's 1960s hits ("Blue Velvet,"
"Roses Are Red," "Mr. Lonely") have made
him a near cult figure. In Branson he
teams up with the Glenn Miller Orchestra
and various family members, including
his mother, Dorothy, who sings and dances
her way into audiences' hearts.

RIDING BUCKSHOT

Sometimes the newer and smaller
shows are the most fun; maybe they try
harder. Sunny of the "Wild West Show"
is up at dawn to say good-bye to departing
bus tours, then singing, dancing, riding,
and waving to the audience till the show
ends at 10.30 at night.

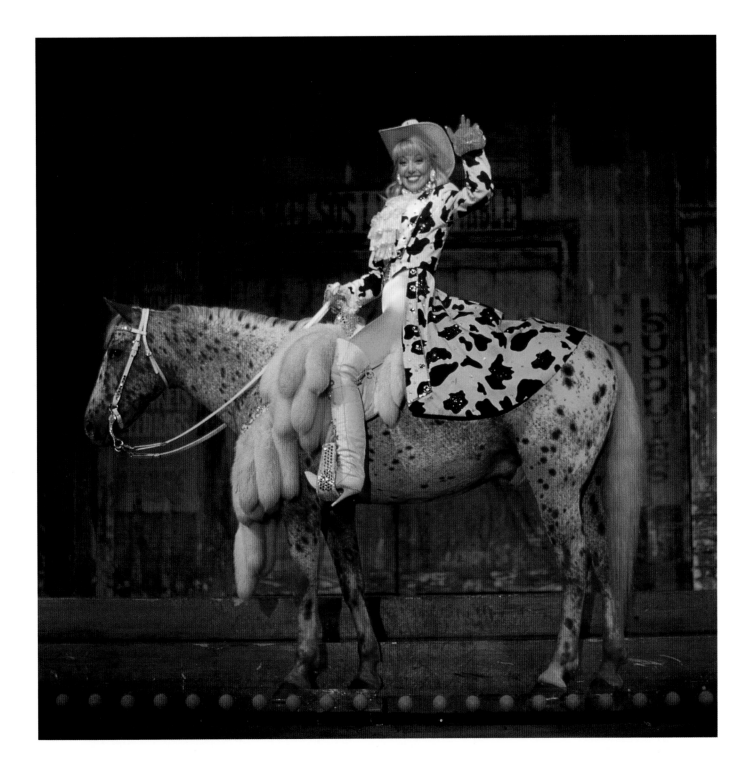

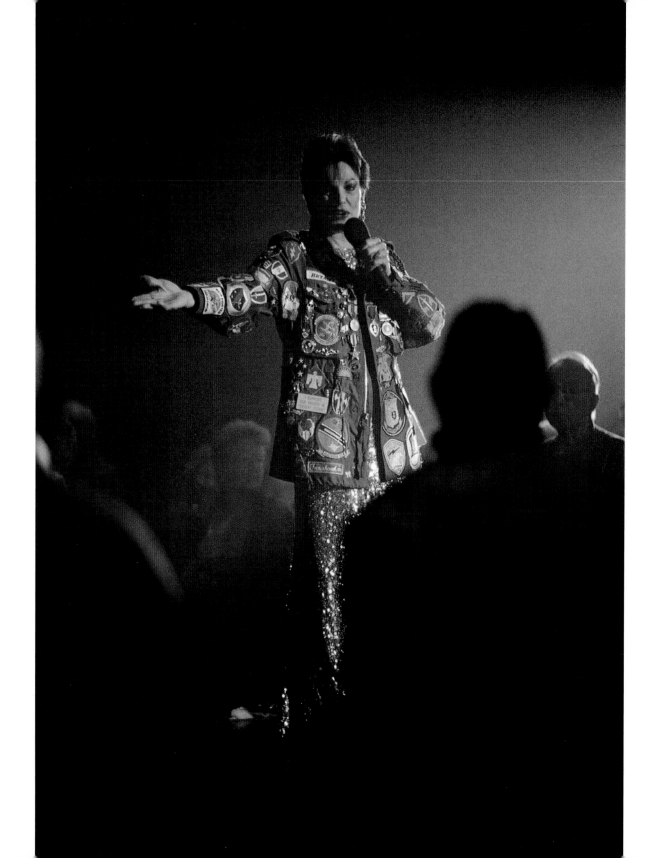

WITH FEELING

Anita Bryant has a loyal audience that remembers her from her days as Miss Oklahoma and runner-up Miss America in 1958. Her show features her singing, along with a lot of her personal reminiscences and strong political and religious views.

PROUD INTERMISSION

Charley Pride is one of the few pure country entertainers to come to Branson in recent years. He is a member of the Country Music Hall of Fame, and his hits, such as "Does My Ring Hurt Your Finger?" (1967) are well known to his audiences, who often sing along with him.

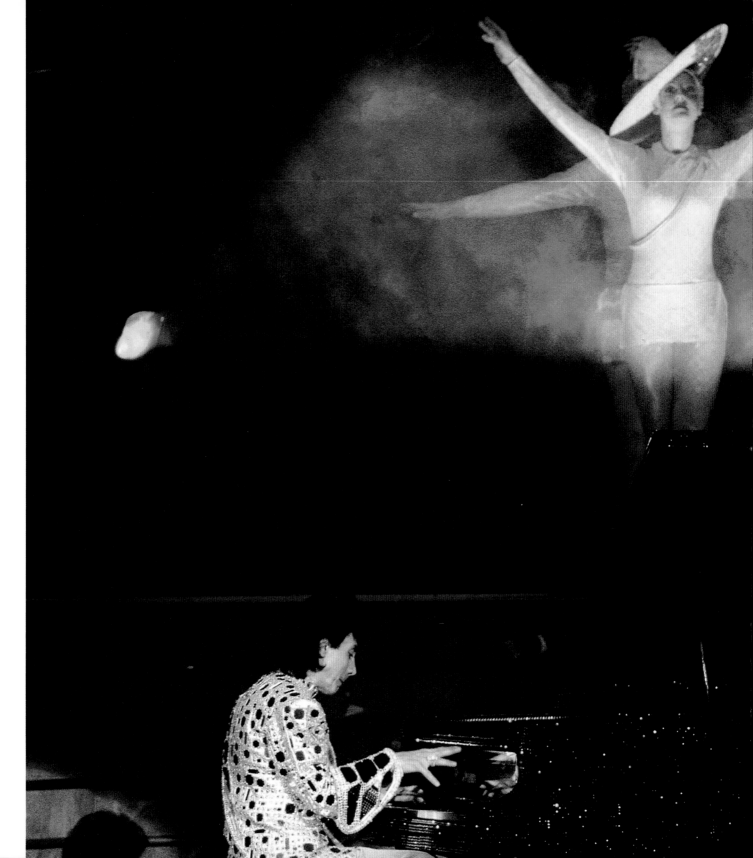

DINO AND DANCERS

Dino Kartsonakis's "Music for All Time"
show at the Grand Palace rivals Shoji
Tabuchi's for extravagance. Playing a
piano once owned by his hero, Liberace,
Dino weaves his magic with the help
of a troupe of dancers, elaborate stage
settings, and wild laser displays.

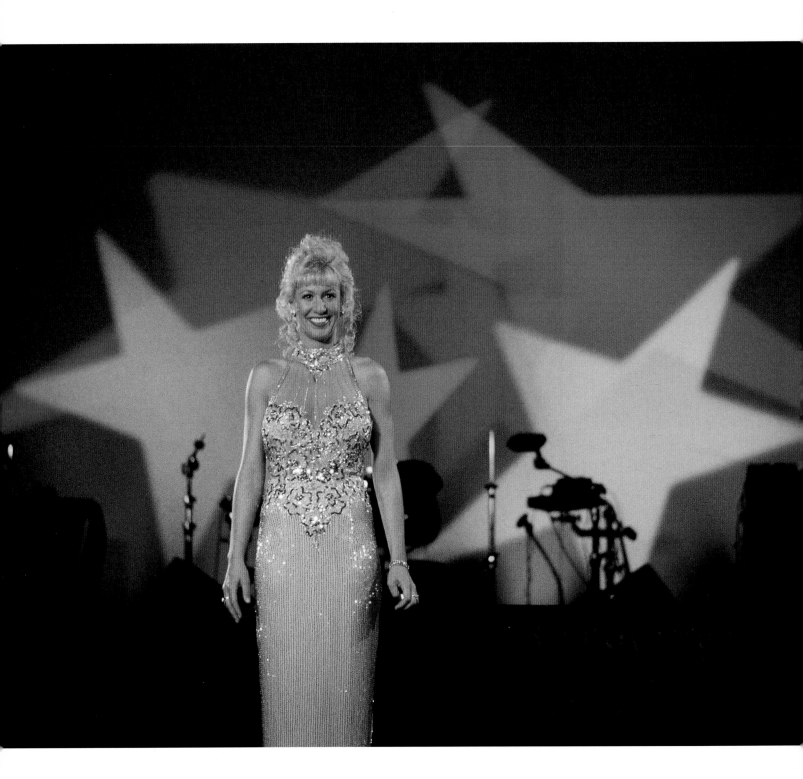

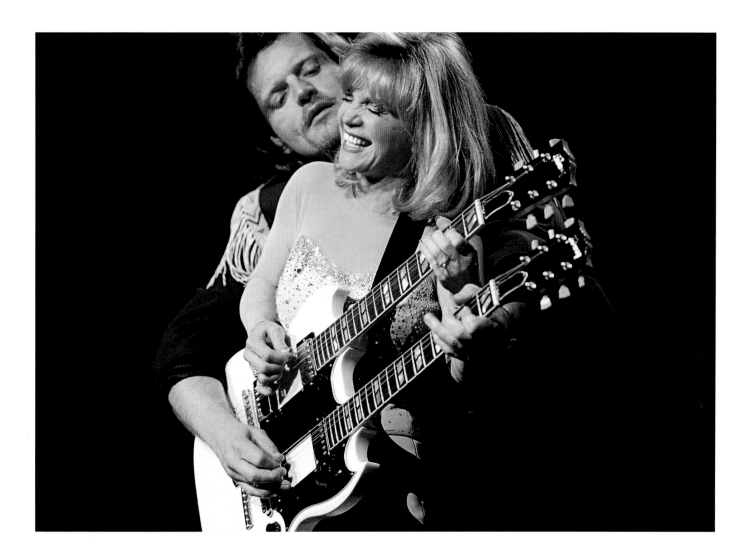

JENNIFER IN THE MORNING

Jennifer Wilson headlines one of Branson's most popular morning shows. Her energetic blend of Broadway and hillbilly— as well as her Betty Grable style—made her a natural to be spokesperson for USO.

WORKING OUT

Although she doesn't have her own theater, Barbara Mandrell has regularly played short engagements at the Grand Palace, singing her greatest hits and showing off her versatility as a musician.

PORTRAIT OF WILLIE

"Box," shown here outside the Boxcar Willie Museum and Gift Shop, represents the older Branson style—simple shows featuring good hillbilly music, corny jokes, and patriotic homilies.

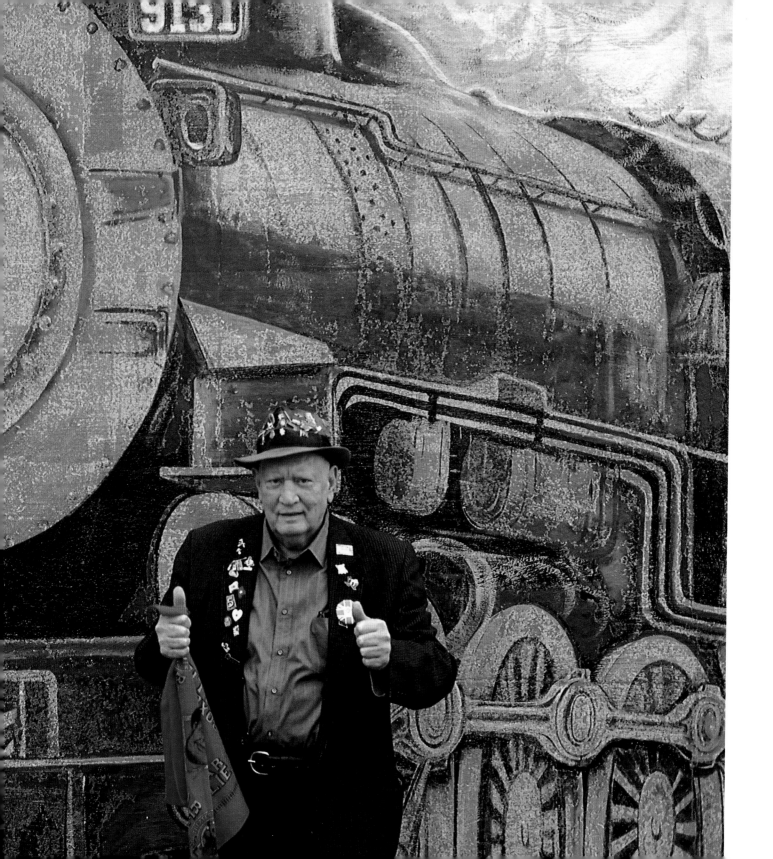

It's a good idea in show business to know your audience, but Branson's theaters and stars take that maxim an extra mile. The shows reflect the fact that the over-65 crowd can make up as much as half the audience. Many of the performances and music hail back to the early days of rock-and-roll and before, with an emphasis on big bands like the Glenn Miller and Lawrence Welk orchestras and singers like Bobby Vinton and Tony Orlando. And there's an abundance of old-time wholesomeness—hard to find nowadays—in acts from the Osmond Family to the Presley Jubilee.

Tours, of course, are crucial, often accounting for as many as 1 out of every 4 or 5 tickets—a statistic not lost on the performers. The stars often salute individual tour groups from the stage, and many rush to the buses or lobbies after the show to greet their fans. The fans naturally love the extra attention and the chance to make a personal connection with the performers. And entertainers like the goodwill it creates, the kind of warmth and positive memories that keep the buses rolling into town.

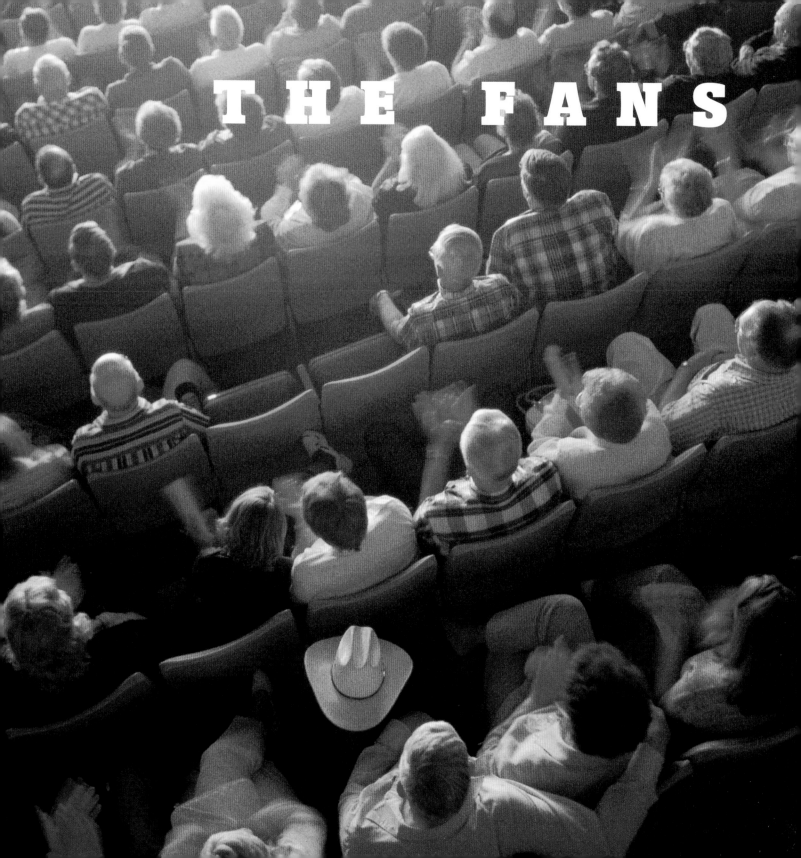

THE FANS

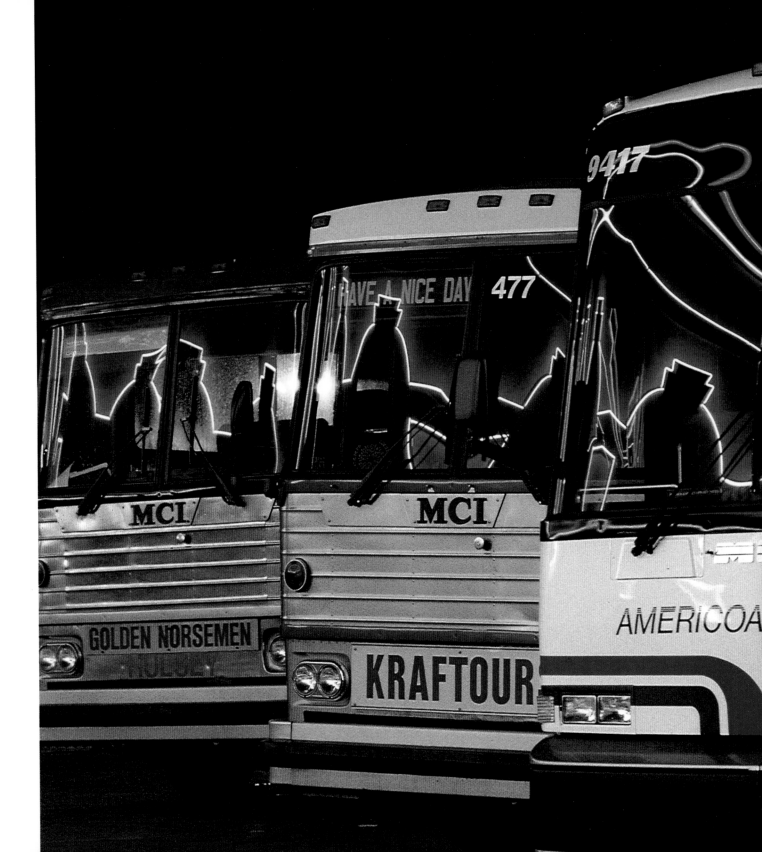

IN THE WINGS

Motor coach tours, from all parts of the United States and Canada, make up about 10 percent of Branson's visitors, and 20 to 50 percent of the audience at some shows. Most performers make a special point of acknowledging each tour somewhere in their show.

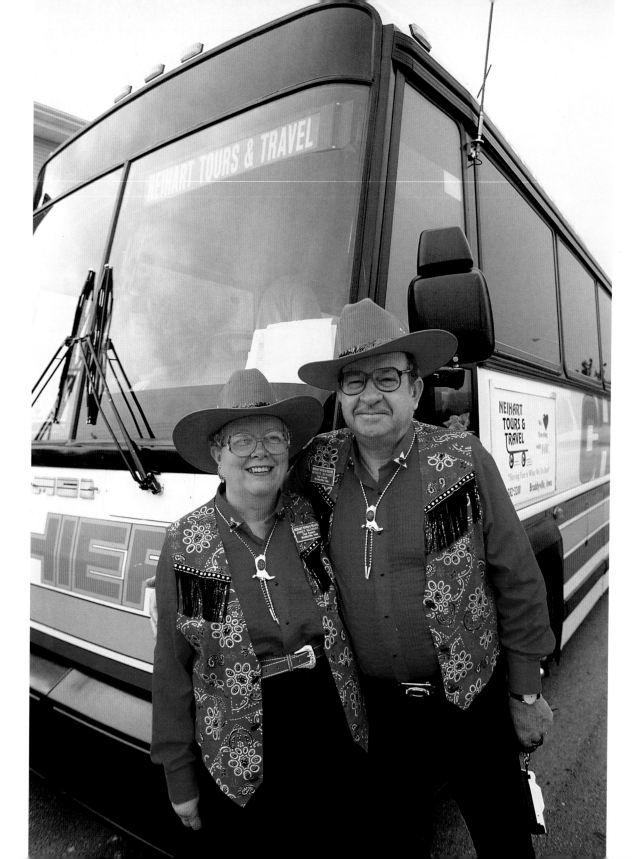

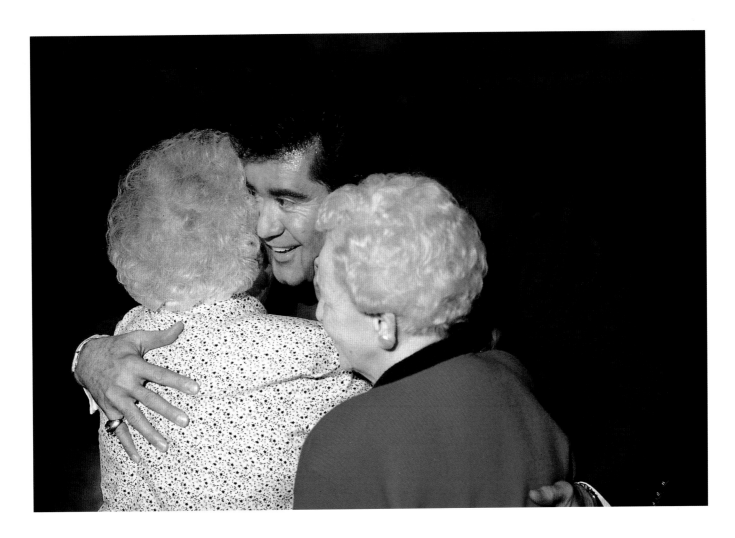

SMOOTH OPERATORS

Janet and Monroe Neihart run Neihart

Tours & Travel out of Braddyville,

Iowa. They are on the road about 220

days a year, and have been leading

annual trips to Branson since 1986.

ADORING FANS

Branson fans love Wayne Newton, but

only a lucky few get a chance to meet

their idol up close and personal. These

ladies got their hugs when the performer

went into the audience to sing for them.

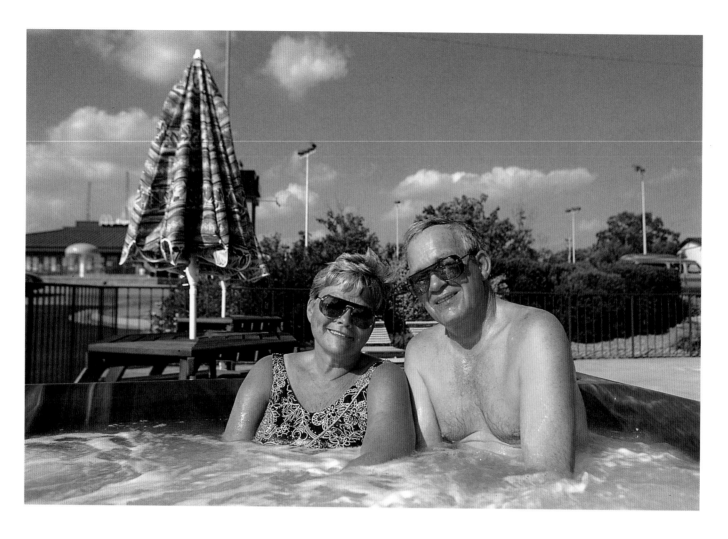

DOWN TIME

Visitors often take in three shows a day—morning, afternoon, and evening. The hours in between are free for less arduous pursuits. This Minnesota couple is taking a well-deserved break in their motel pool.

POLKA PARTY

At the Welk Champagne Theater polka festival, thousands of fans come from all over the world to dance to Myron Floren, Walter Ostanek, Verne and Steve Meisner, the Jodie Mikula Orchestra, and other international polka stars.

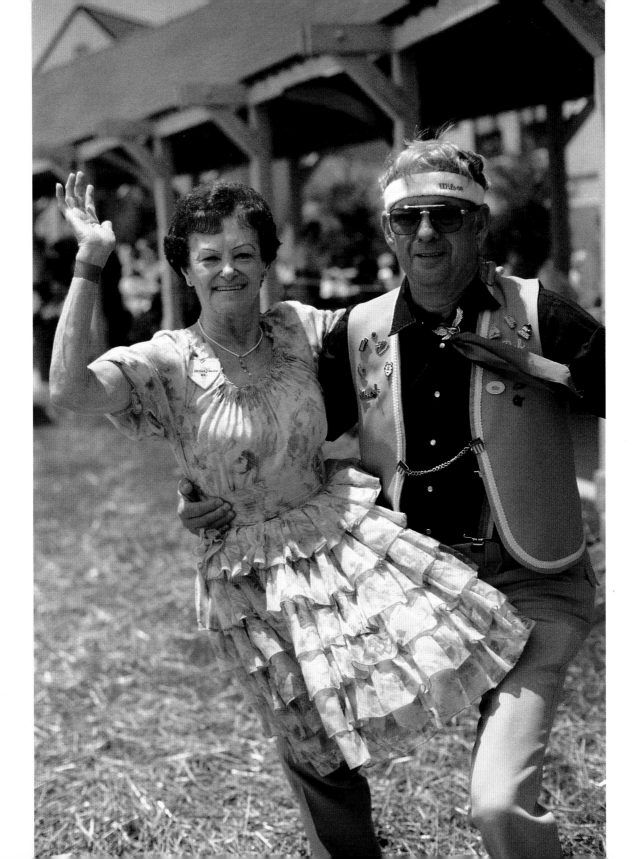

PERSONAL BEST

One of the perks of coming to Branson on a tour bus is that many entertainers visit after the show, where they may give a short talk, answer questions, or sign autographs. Comedian Yakov Smirnoff is a master at charming tour audiences.

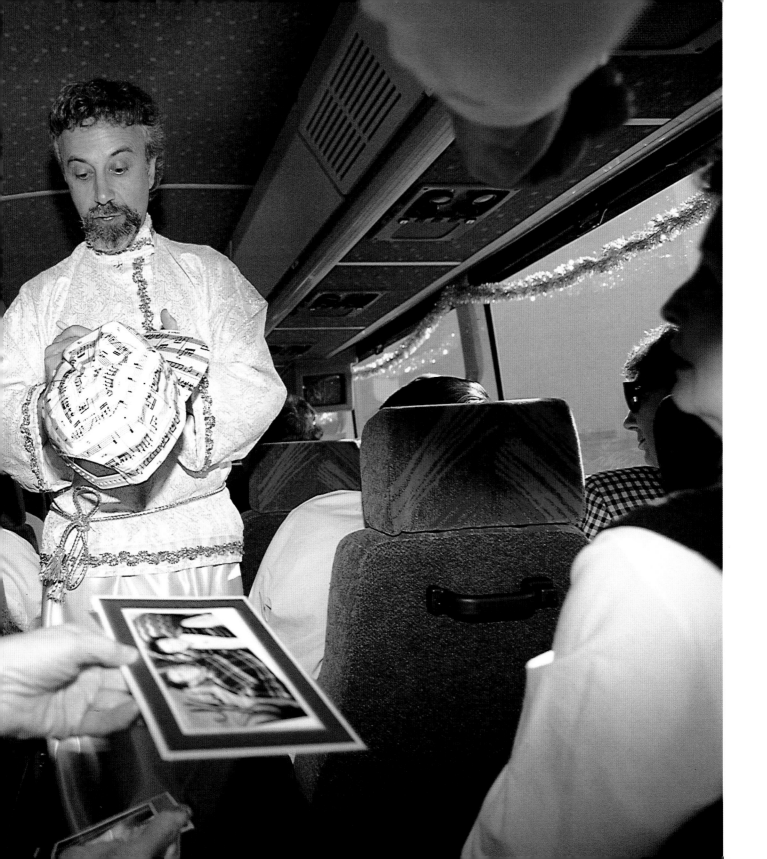

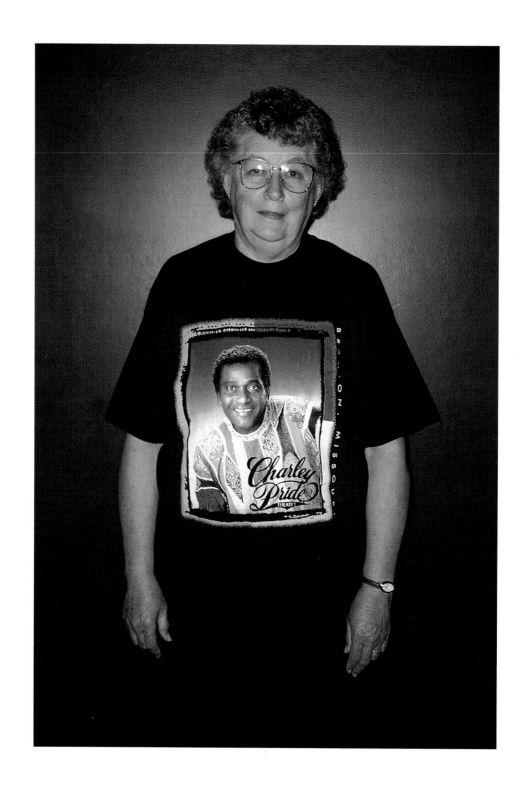

WEARING CHARLEY

There's no dress code in Branson, so visitors happily display their opinions and passions on their clothes. T-shirt themes range from the patriotic and religious to strictly entertainment.

PATRIOTIC SALUTE

Most shows take a moment to acknowledge the men and women who have fought for their country. Entertainers often ask veterans to stand for the applause and appreciation of the audience.

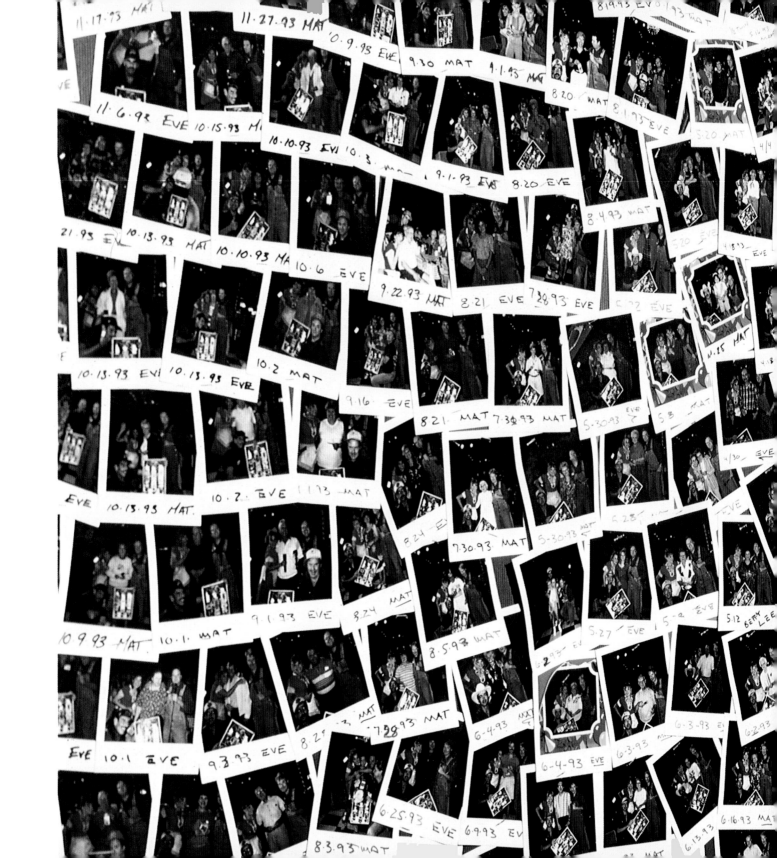

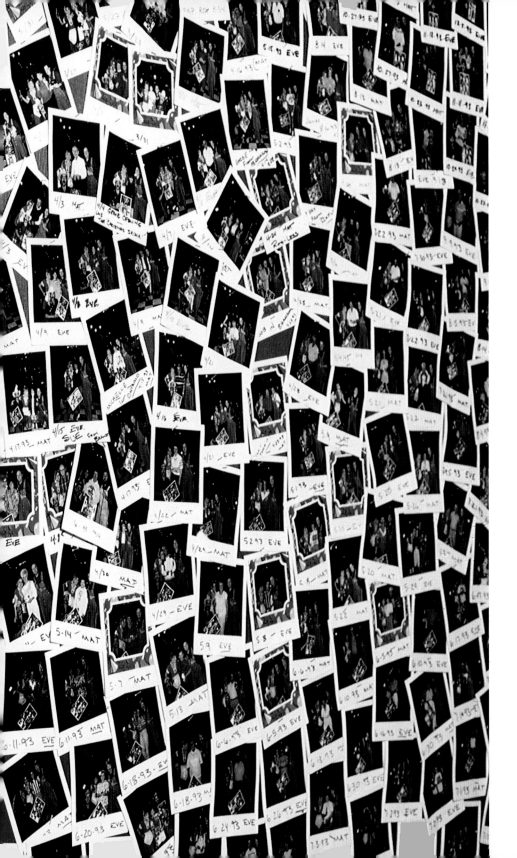

FAN RECOGNITION

The cast of the Tony-nominated Pump Boys and Dinettes musical, which appeared on Broadway in the early 1980s, takes Polaroids with audiences after each show and displays them on a wall in the theater.

No doubt the stars bring in the crowds, but it's often the supporting cast that keeps the audience glued to their seats. Aside from the world-class musicians, singers, and dancers who are the backbone of Branson entertainment, there are children who perform, dogs that jump through hoops, and comedians who juggle rubber chickens and lurch about on unicycles. Jim Stafford has Balloonomaniacs, girls who make funny shapes from balloons during intermission; the Osmonds have a troupe of trained dogs.

For the shows that have no single headliner, the supporting cast can just about steal the show, singing every song and dancing every dance. Witness the Dixie Stampede, where the real stars are the horses and the home-cooked barbecue served to the audience.

Some shows are downright corny—no one does hillbilly humor and music like the Baldknobbers. But other shows are sophisticated enough to be in Las Vegas; many, in fact, were and some still are: Wayne Newton, Andy Williams, and Barbara Mandrell, to name just a few.

THE SHOWS

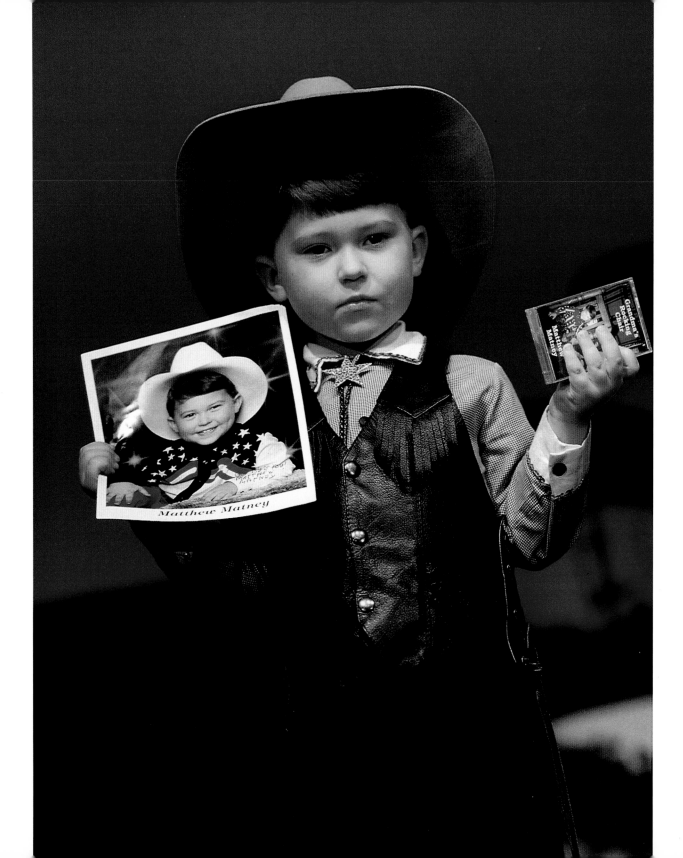

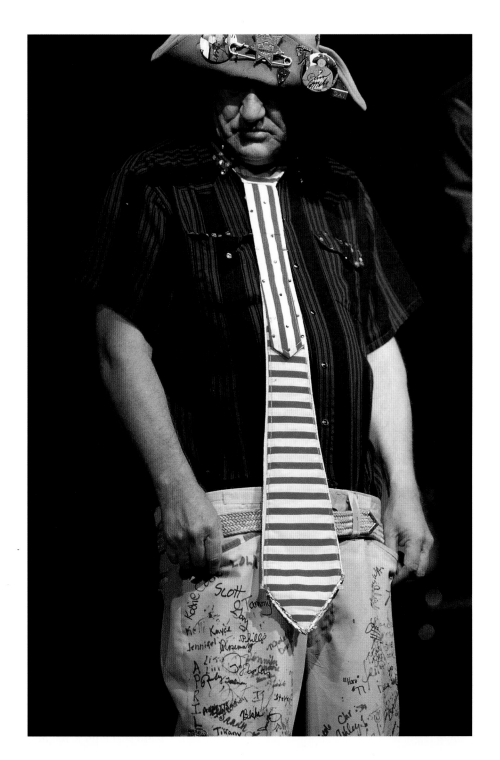

OLD AND YOUNG

Veteran comedian Stub Meadows does his thing as Droopy Drawers at The Baldknobbers, one of the oldest continuously running musical theaters in town (left), while five-year-old Matthew Matney performs at the Barbara Fairchild Theater (opposite). An important part of any entertainer's income, regardless of age, comes from sales of CDs, songbooks, and other products.

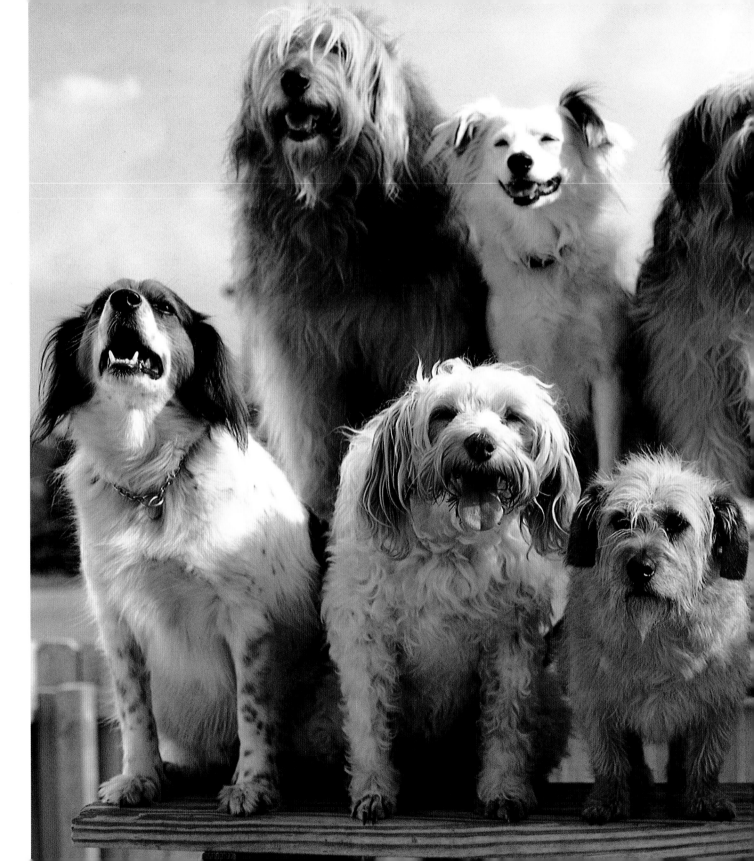

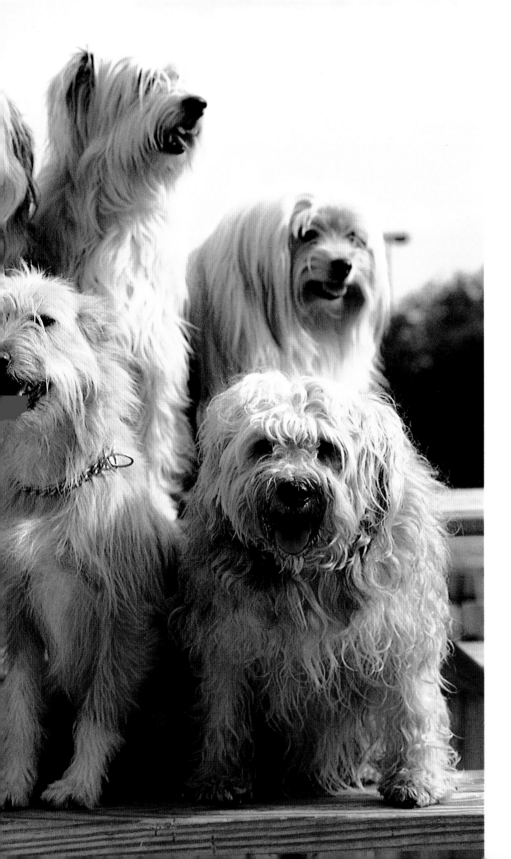

A DOG'S LIFE

*Bob Moore's trained dogs are all stray
mongrels. At the Osmond Family Theater,
they walk tightropes, jump through
hoops, and kick him from behind. The
dog in the middle (bottom row) knows no
tricks; he just sits onstage and barks.*

OLD-TIME RELIGION

*Host of the popular Sunday show
"The Grand Old Gospel Hour," Dr. David
Stauffer provides a rousing mixture
of music, comedy, preaching, and soul-
saving (right). "The Promise," the pageant
of the life of Jesus Christ performed
year-round at the Will Rogers Theater
(opposite), is a further reflection of the
deep influence of religion and religion-
based entertainment in Branson.*

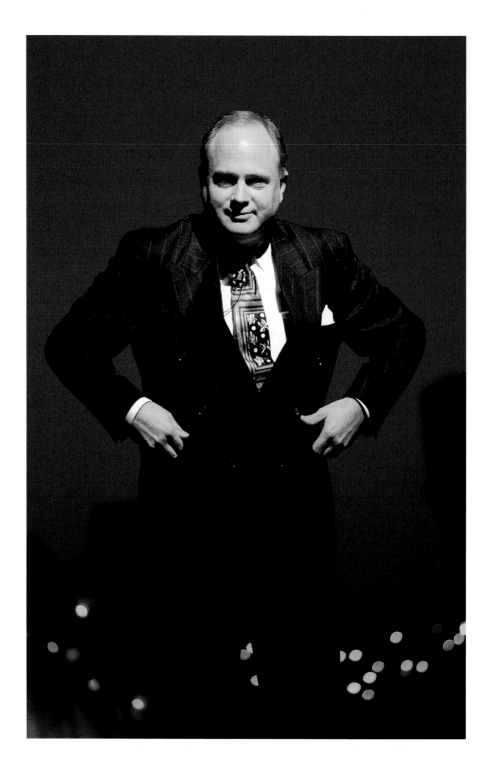

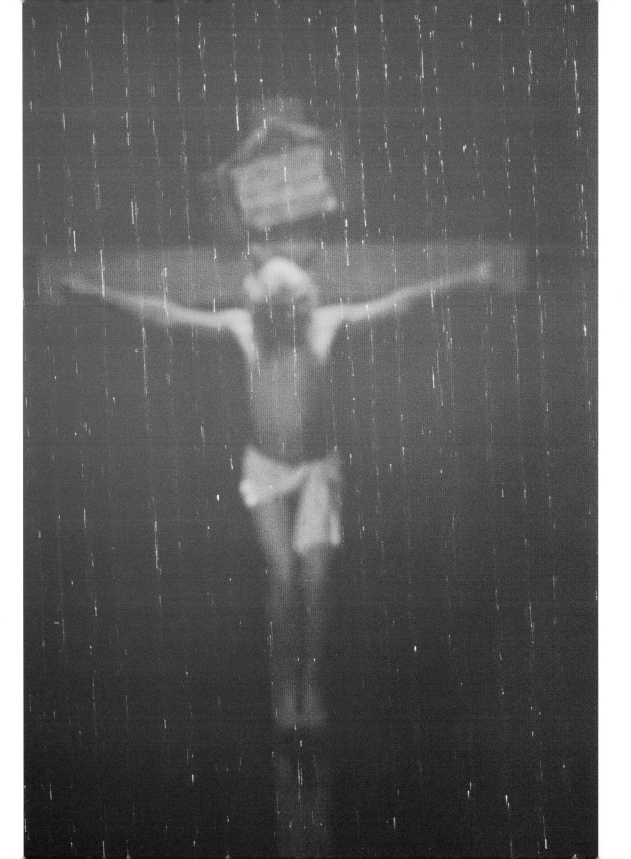

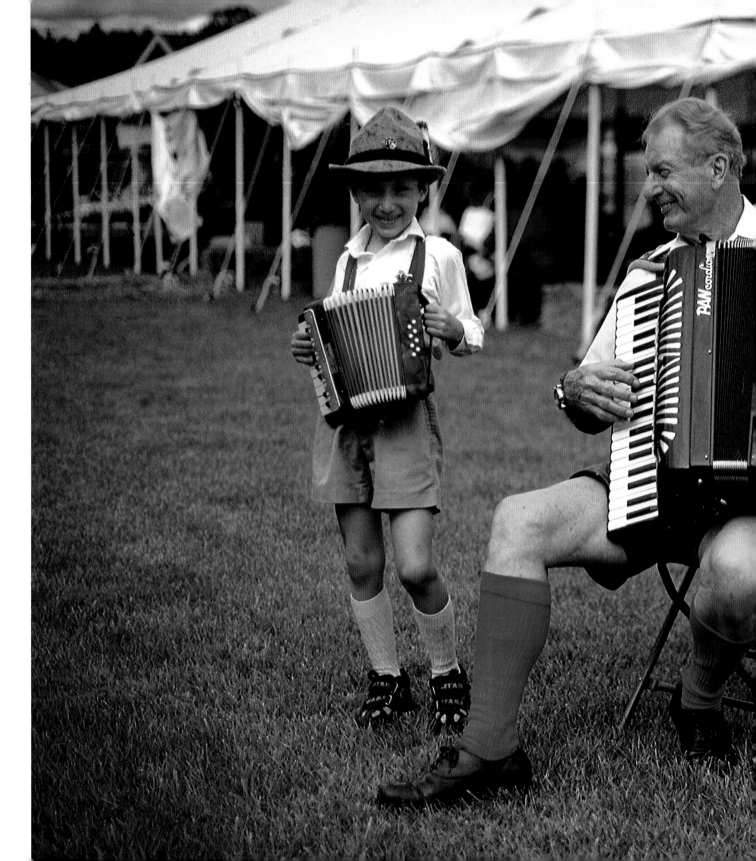

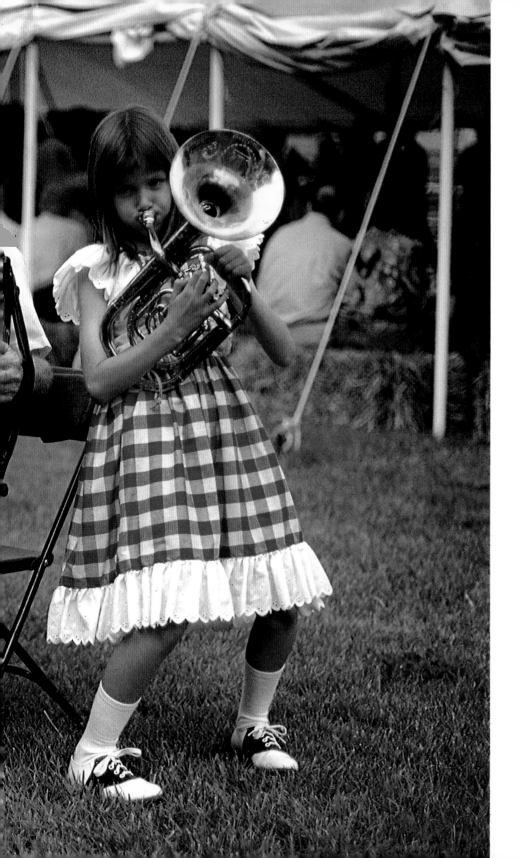

POLKA JAM

Myron Floren, a legendary accordionist, was a star of the Lawrence Welk television show from 1955 to 1982. He's a regular visitor to Branson, though he tours worldwide for most of the year. Pictured with him are Henry and Grace, the children of Bill and Gail Lennon.

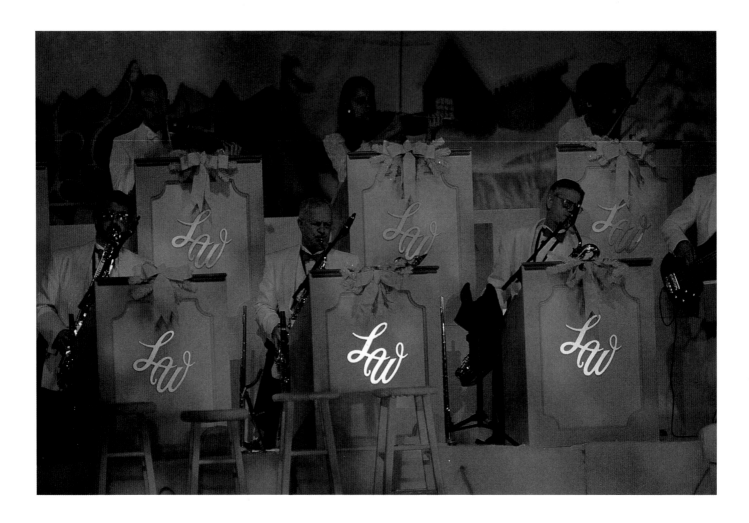

LUSH LIFE

The Welk Champagne Theater production
is one of the most lavish. It may not
be as flashy as some, but it's musically
polished and very sophisticated.

NORTH VS. SOUTH

The Dixie Stampede, owned by Dolly
Parton's Dollywood company, combines
trick riding, a barbecue dinner, and
special events such as pig and chicken
racing—all to a Civil War theme.

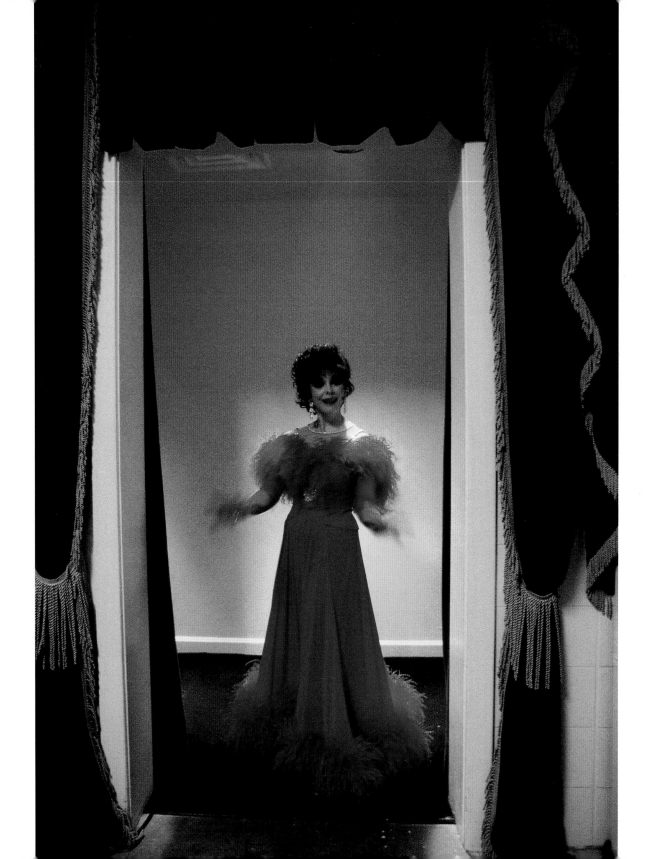

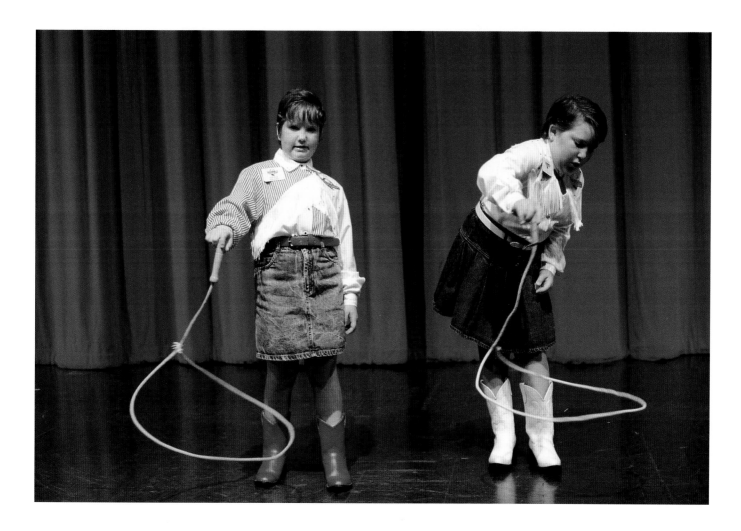

ALL IN THE FAMILY

Shows are frequently family affairs, for
the performers as well as for the audience.
At the Grand Palace, Dino Kartsonakis's
wife, Cheryl, sings and dances and is
an integral part of the show's success.

BREAK TIME

Intermission entertainment is often
provided by children, such as these crack
lasso artists at Country Tonite, a lively
musical review packed with lasers,
country music, and cowboys and cowgirls
who can sing, dance, and twirl ropes.

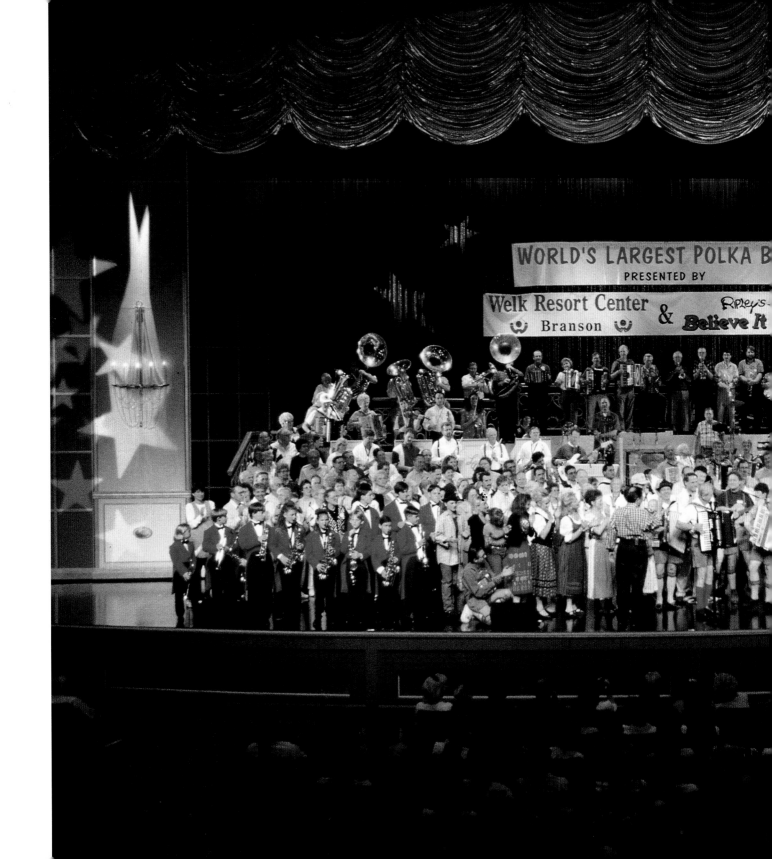

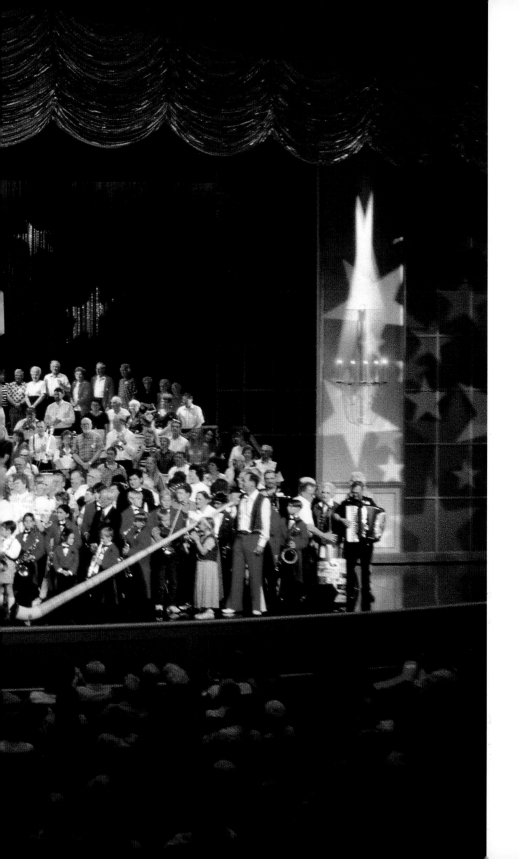

RECORD SETTER

For its annual spring polka festival, the Welk Champagne Theater gathers more polka players in one spot than any other group in history (certified by Ripley's Believe-It-or-Not). The band consists of world-famous professionals, serious amateurs, and a few ringers.

HOME ON THE RANGE

The Sons of the Pioneers show is a tribute

to Western music, lore, and film (opposite).

The band plays all its hits and also takes

its fans back to the time when cowboys were

our Number One heroes. The real stars

of the Dixie Stampede (left) are thirty-two

beautiful horses. They run fast, do their

tricks, and generally put up with the noise

and excitement of the large crowds.

There's a lot more to Branson than music. Long before the first theaters were built, people were drawn to the area by its natural beauty and the outdoor activities that were available—fishing, hunting, boating, and camping. Shepherd of the Hills, one of the earliest Branson attractions (1960), re-creates a frontier village and offers an outdoor theater.

And then there are the shopping outlets and Silver Dollar City, a 40-acre theme park; with 2 million or so visitors a year, it qualifies as the town's largest single tourist attraction. Many of the the theaters are on the main strip, Highway 76, but so is the Boxcar Willie Museum and Gift Shop, go-carts, bungee jumping, and most anything else you'd find in a booming tourist town.

The various attractions are a nice complement to the musical entertainment. In the afternoon you can drop your grandparents off at the Mel Tillis show, then take the kids swimming at White Water. After an early dinner at B. T. Bones, you all can play a little miniature golf or take in Jim Stafford's show. There really is something for everyone.

THE OTHER BRANSON

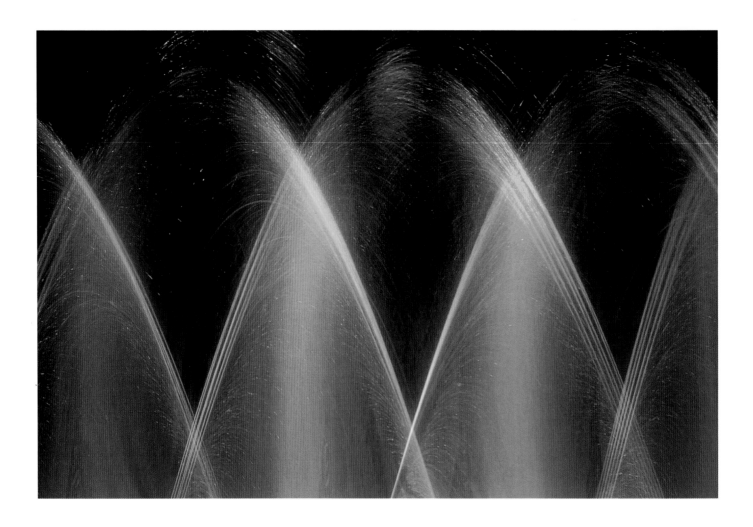

WALTZING WATERS

This tiny theater on the Strip features dramatic water sprays three stories tall and twice as wide. They're backed by a laser light show and prerecorded show tunes.

WRIGHT FAMILY BAND

Some of the most genuine country music takes place at Silver Dollar City, a huge Western theme park. During the summer it offers country music bands—some well known, others regional and amateur.

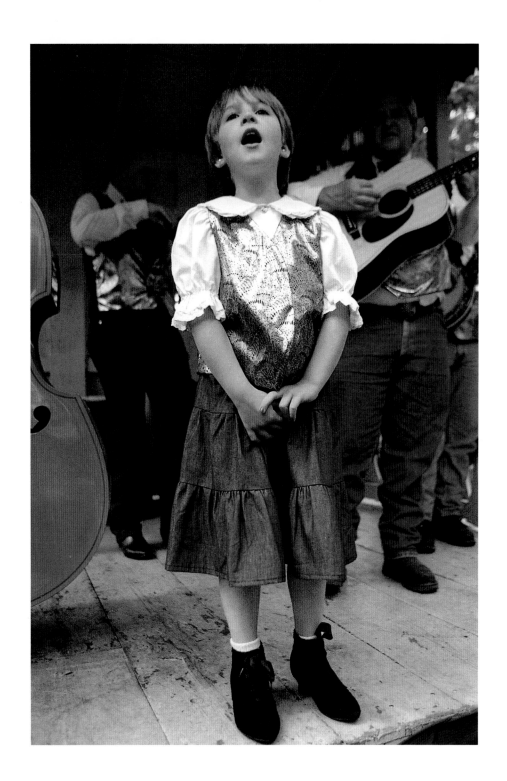

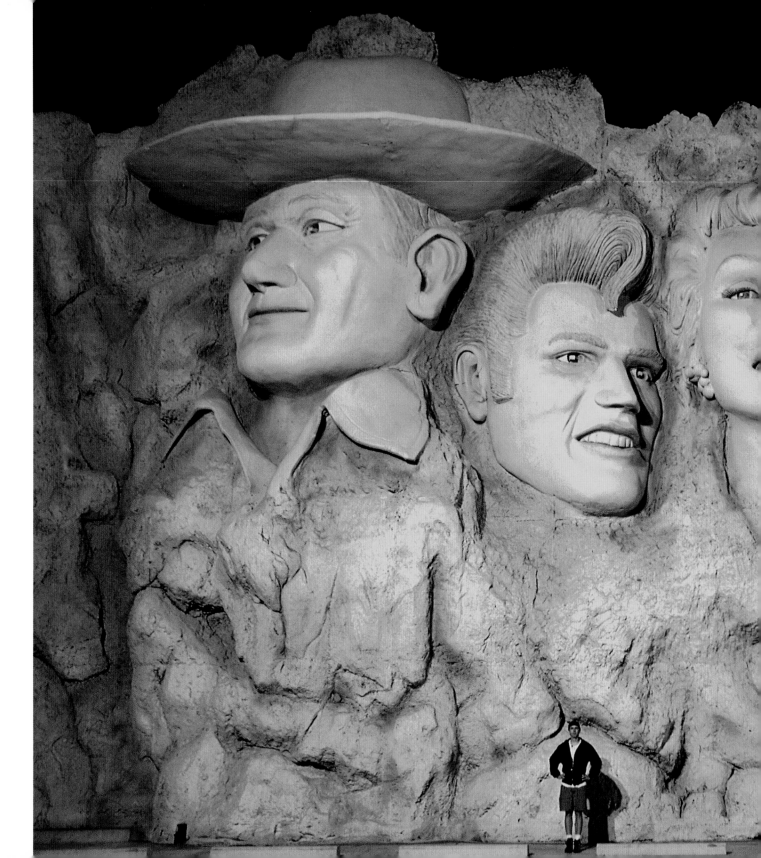

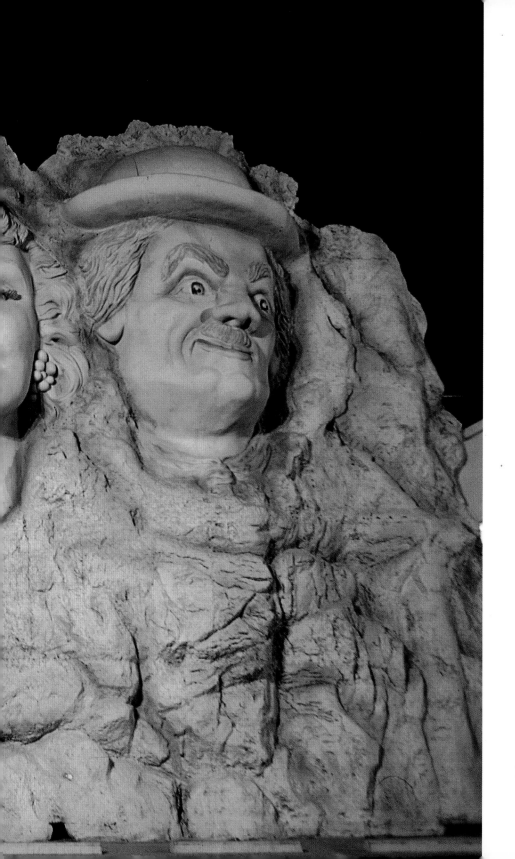

MOUNT HOLLYWOOD

The outdoor wall of the Hollywood Wax Museum on Highway 65 features John Wayne, Elvis Presley, Marilyn Monroe, and Charlie Chaplin in a send-up of Mount Rushmore. Hand-built in Florida of foam and fiberglass and transported in sections to Branson, the wall is 115 feet long and 50 feet high.

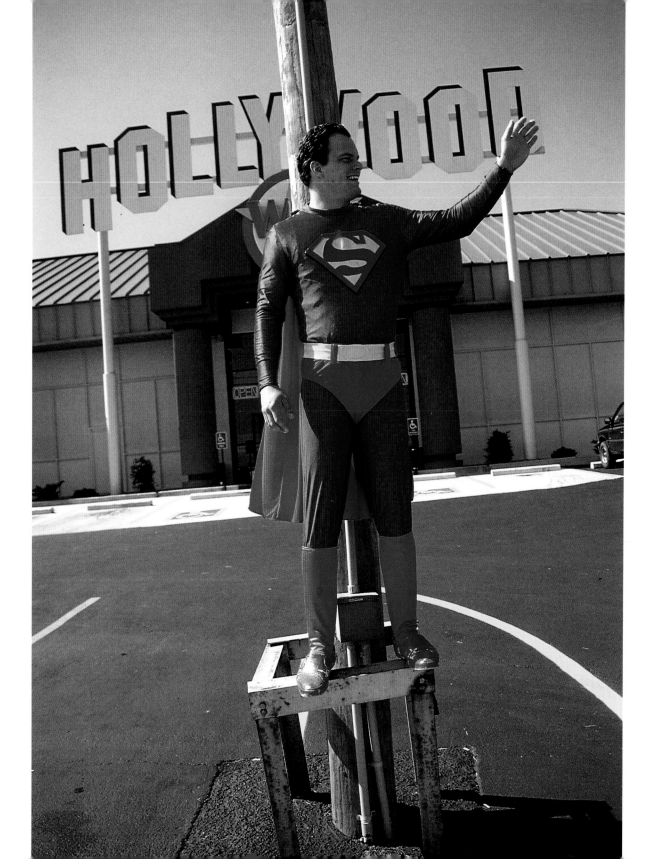

ON THE STRIP

*Highway 76 is packed with local
hangouts such as White Water, the
largest water park in the region and a
favorite with children. It's complete
with swimming, rides, gift shops, strip
malls, shopping outlets—and even
the occasional visit from a superhero.*

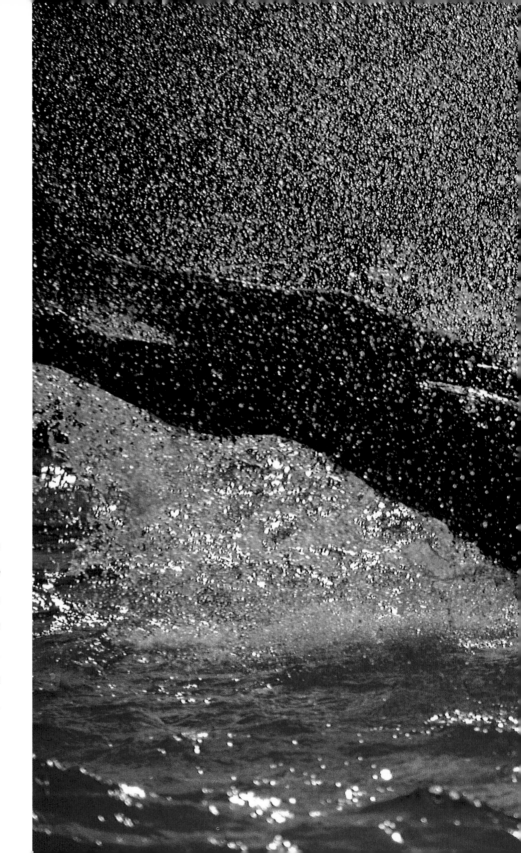

WET AND WILD

White Water's rides are literally breathtaking, from Surfquake, a 500,000-gallon wave pool, to Paradise Plunge, a 207-foot triple-drop slide. There's just plain swimming for the less adventurous as well.

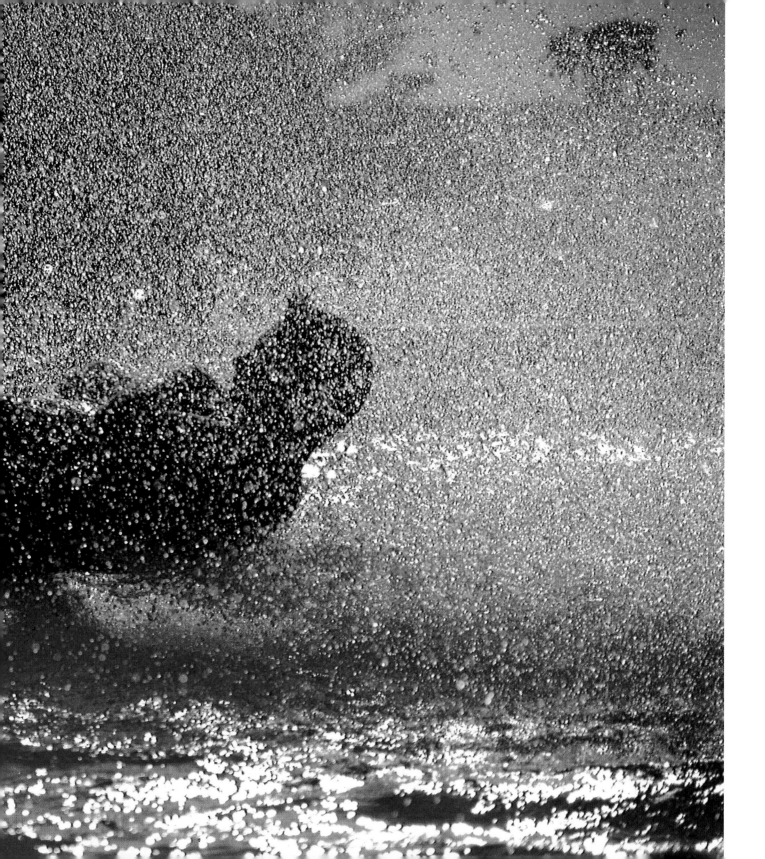

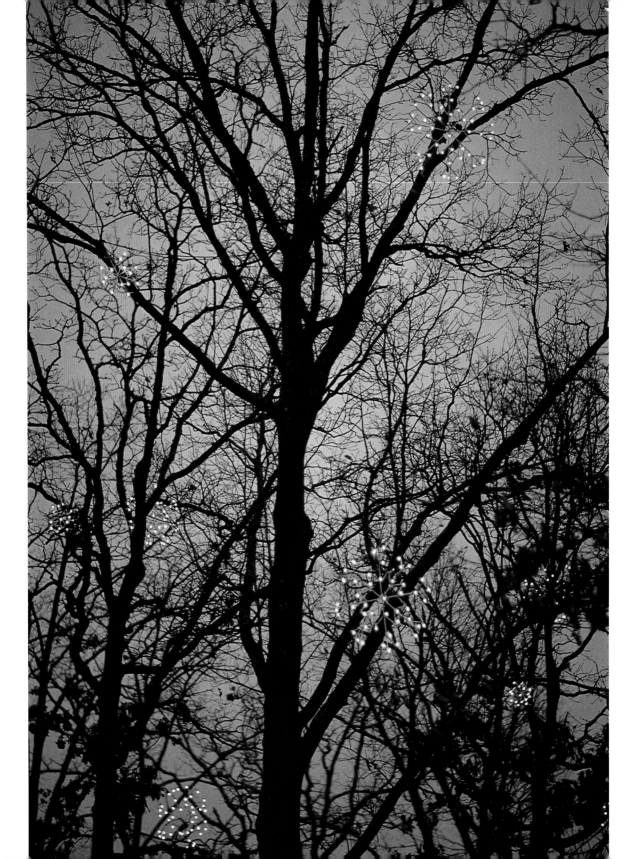

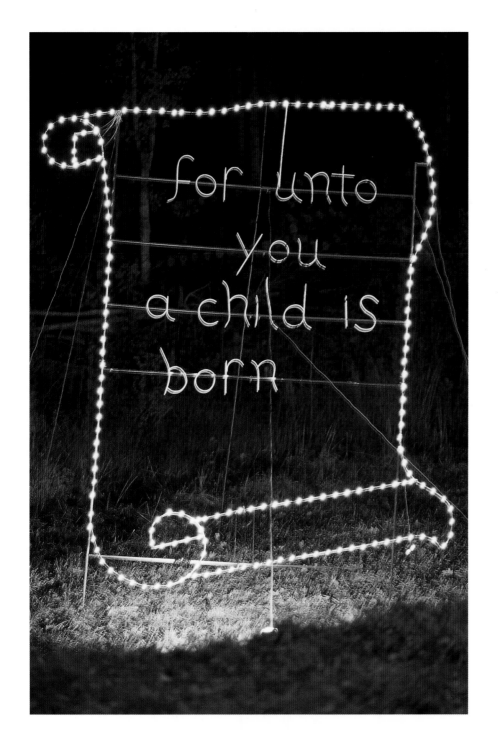

ALL THAT GLITTERS

The town pulls out all the stops around Christmas, offering weeks of special events and attractions. Every building and tree seems to be draped in holiday lights. The Festival of Lights Parkway, on the north side of town, is lined with religious and holiday greetings.

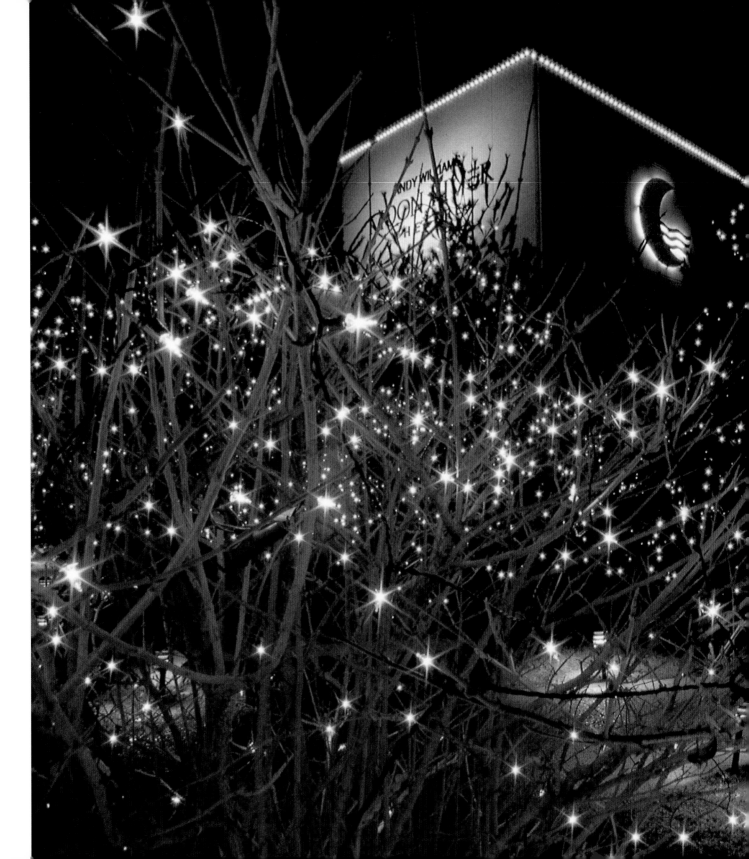

THE BRIGHTEST LIGHT

During the Christmas season, theater
design is taken to new heights: Many
exteriors are virtually covered with lights
and signs celebrating the season.
Perhaps the most striking display is at
Andy Williams' Moon River Theater.

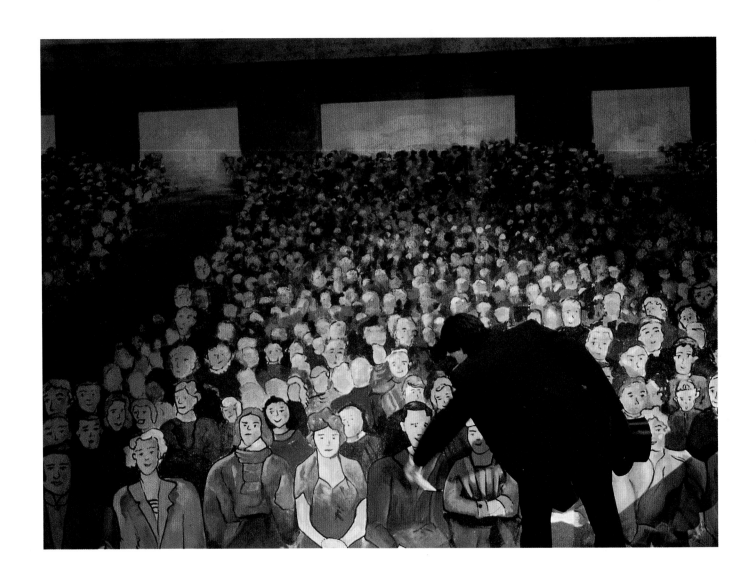

PHOTOGRAPHER'S NOTE

I used Canon EOS-1N cameras and lenses ranging from 20mm to 400mm.

Most of the time I used existing light and Fujichrome film—

100 I.S.O. outdoors and 400 I.S.O. (usually pushed one or two stops) indoors.

Occasionally, I used on-camera flash and negative film—Fujicolor 400.